Yani's Monkeys

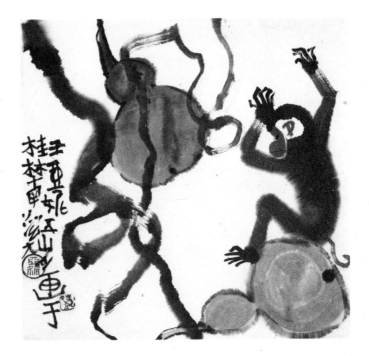

Yani's Monkeys

FOREIGN LANGUAGES PRESS BEIJING

First edition 1984

ISBN 0-8351-1179-2

Published by the Foreign Languages Press
24 Baiwanzhuang Road, Beijing, China

Printed by the Foreign Languages Printing House
19 West Chegongzhuang Road, Beijing, China

Distributed by China Publications Centre (Guoji Shudian)
P.O. Box 399, Beijing, China

Printed in the People's Republic of China

Foreword

Not long ago, I went to Wang Yani's painting exhibition held in Beijing's Cultural Palace for Nationalities. I had the pleasure of seeing her paint on the spot. What struck me most in her painting was the liveliness and innocence of a child's mind and the complete absence of any affectation. By talking to this young girl of the Zhuang national minority and her father, I acquired some information that shed light on the matter of art education for children.

To educate children in art, we should, first and foremost, try to understand their pure and spontaneous responses and their ways of expression. Forcing methods of adult training on them will not work, and will, in fact, ruin the spontaneous nature of a child. Children's paintings made under the influence of adults are usually worthless, for they tend to lose the spontaneity typical children's paintings may possess. Children, after all, are still children. They should not be bound by the conventions of the grown-ups. Instead, they should be allowed to blaze a path of their own.

Yani's paintings are expressive, lovely and full of life. This, of course, cannot be detached from her own ingenuity and intelligence. But the success should also be credited to the correct instructions given her by many veteran artists including her father, Wang Shiqiang. Instead of making her copy the masterpieces of well-known painters, they allowed her to paint according to her own fancies, her own experience of life, and her own rich imagination. All this has given full scope to the simplicity, liveliness and innocence of Yani's heart. Intriguingly naughty, lively and dreamy, all the monkeys Yani

paints are personified. They vividly give expression to the life of those whom this young painter is interested in and familiar with. What is more, they are an artistic condensation of the child's love for life.

People who regard her as a prodigy may be struck most by her extraordinary sensitivity to life and her remarkable ability to express herself. But, in my opinion, her noteworthy achievements are largely the consequence of her repeated and untiring practice in painting. She has made more than 4,000 paintings in a period of three years, which is quite a miracle for a young girl. "Practice makes perfect." This saying, I firmly believe, reveals the secret of her sensitivity in appreciating beauty. Wang Yani's works, with their well-balanced composition, appropriate spacing, fluent brush strokes, striking use of colours and life-like images, suggest that she has at least mastered some of the most important principles and skills of painting. Even the inscriptions and her signature are never carelessly thrown on paper, but are a product of careful consideration. Yet it would have been impossible for her to develop these talents to such an extent without the correct guidance of the older generation.

Here I would like to close this foreword with the hope that Wang Yani will bear this in mind: the more you accomplish, the more modest you should be; study, study and study, and always make new progress.

JIANG FENG
Chairman of the Union of Chinese Artists and President of the Central Academy of Fine Arts
June 10, 1981, Beijing

The Heart of a Child

The moment you open this album you will see different kinds of personified monkeys painted by the brush of a child. Some are picking fruit, some are singing and dancing, and some are playing hide-and-seek. Together they create a lively image without a single repetition. You may find it unbelievable to learn that the artist who brings these monkeys to life on paper is Yani, a six-year-old girl. This is the story of how she came to paint these monkeys.

Yani's Father Discovers Her Interest in Painting

One day Yani happened to be playing in her father's workroom, and every now and then she stopped to watch him at his painting. As she did so, she imitated her father, painting on the snow-white wall

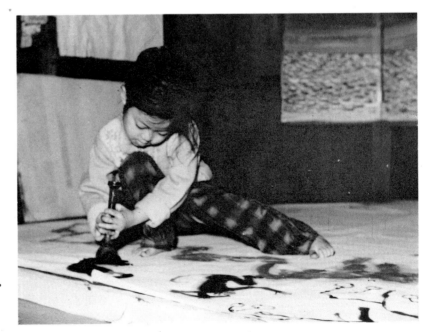

Yani at three.

with a piece of charcoal. After drawing a few circles, she rubbed over the charcoal with her handkerchief, then moved aback a little to survey the work. With her arms akimbo and head tilted to one side, she looked at her own "masterpiece" with great attention before she went forward to add a few more strokes to her not-yet-perfect work.

"Yani, are you a painter?" The laughing voice of an aunt who lived next door came through the open window.

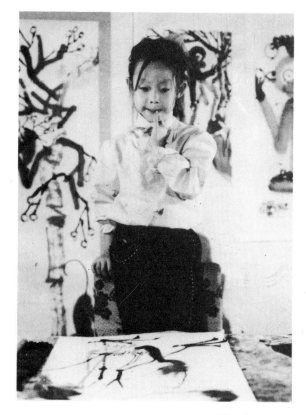

Yani at six.

Only then did Yani's father realize that Yani was also *painting* while he was. How amusing! Yani was copying the adult. "Does she really wish to learn painting?" he wondered. The idea seemed to lighten his mind. "Yani, you are really Papa's treasure," he said, kissing his daughter on her cheeks because he was unable to hide his feelings of satisfaction.

At the thought of being recognized in the act of painting, Yani felt quite pleased with herself. "Daddy," she said, feeling her father's face with her two little charcoal-covered

hands, "I'll draw a picture of you."

"Draw a picture of me?" Her father smiled back an answer, seeming a wee bit puzzled.

"Right." She took a stool and placed it in front of her father. "Sit still here, will you?"

Now the father was acting as the daughter's model.

Yani began to make a portrait of her father with the air of being a professional artist. "Daddy, watch me, please." The father was sitting still, his eyes fixed on the little painter. He was pleased to see his daughter, in a seemingly serious manner, making a picture of him.

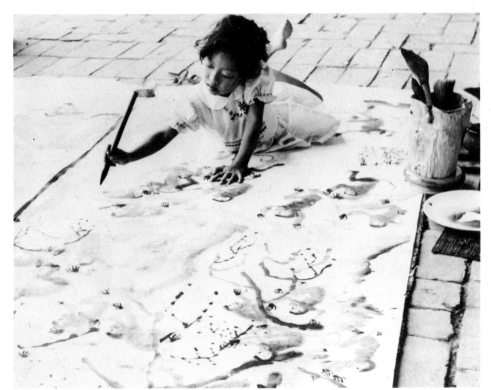

Yani at four.

Yani with her family.

A minute later, Yani was through with her job. "Daddy, doesn't it look like you?" she asked proudly.

"What a painting!" the father thought to himself. "It is just a stone surrounded by many unconnected lines." Nevertheless, he was pleased at the thought that she was just now painting with the authority of a person who knows perfectly what she is doing. He replied, "Yes, well done, well done."

Yani looked at her own painting and then compared it with her father's.

One day she amused herself by smearing charcoal and pigments over one of her father's paintings, completely destroying it. But instead of wanting to scold the girl, her father was gratified by her interest in painting.

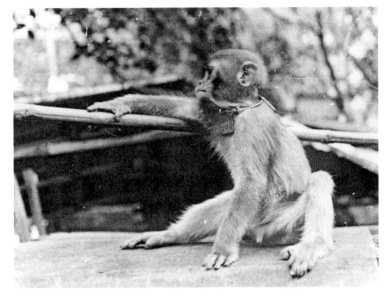

Yani's darling — Lida.

Monkeys Come into Yani's Life

When Yani was two and a half years old, her parents took her to a park. There, there were monkeys swinging, picking lice and climbing rocks. Yani was overjoyed. Turning to a deaf ear to her mother's objections, she insisted that she wanted to go into the cage to play with the monkeys. She finally realized that this was impossible, yet the desire to play with them continued to whirl around in her little head. But how could she possibly play with them? Every time she went to the park she returned home with teary eyes because of the unfulfilled desire.

Obviously, the monkeys had become Yani's treasure. She began to draw many small circles in large circles on the

drawing paper her parents provided. She said these were monkeys, although they looked no more like monkeys than dogs, cats or mice. But however shapeless and strange they might be, those monkeys were much appreciated and treasured by Yani's father, who confirms that what she put on paper revealed his daughter's sentiments. Yani's father did not try to correct her paintings, hoping that she, herself, would eventually be able to turn those shapeless images into vivid and lifelike monkeys.

Once when Yani and her father were strolling along a river bank, she began to gather a great many pebbles. "What are you picking up those pebbles for?" her father asked.

"They are not pebbles. They are monkeys." Yani explained. "Look," she continued, pointing to what she had gathered. "This is the nose of a monkey and that is its eyes. This is a monkey looking at dragonflies, and there baby monkeys are cuddling in their mothers' arms to get milk. Can't you see, Daddy?" she asked.

Strange enough, these pebbles were suddenly transformed in her father's eyes into beautiful monkeys.

Deeply touched by Yani's sincere sentiments and feelings, he bought her a baby monkey. From then on the monkey has been under the good care of Yani. She nicknamed it "Lida." She feeds the female animal herself, and has fun with her every day.

After that, Yani's "shapeless" monkeys began to take shape. First, they were provided with round heads, then hands and feet. Several days

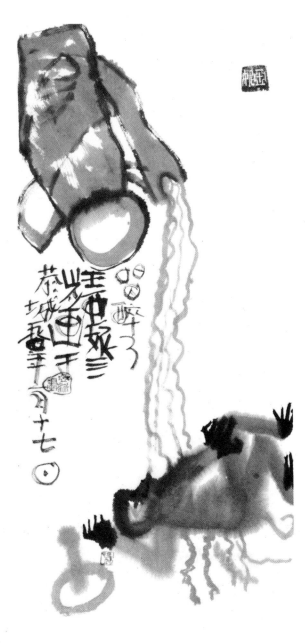

"Dead Drunk."
33cm × 68cm at four.

later, they were merrily swinging by their tails.

How rapidly Yani's works improved! Unlike the way adults reveal their thoughts, Yani expressed her sentiments and feelings by creating different kinds of images on paper. These possessed the liveliness and richness of life and her own individual imagination, all of which provided an additional ornament to her paintings.

Just a few weeks before, the monkeys Yani produced had no fingers. Now they had, even though the number was sometimes only three or four and sometimes a great many. But, in time, she came to accurately put exactly five fingers on each monkey, for Yani had learned to count.

After she added fingers to the monkeys, she began to put

them to practical use. Clearly, her paintings display different kinds of monkeys grabbing branches, picking fruit, catching lice or having a tug of war. At this time she also started to title each of her paintings, as every one had a story behind it.

One of her paintings shows a scene of a baby monkey catching lice for its mother. She entitled it "I can't find any." Yani thought to herself, "Since I don't have one, how could the monkey possibly catch any? They are doing that merely for fun."

Yani's uncle once came to visit her family. He was very pleased to be treated with a bottle of wine of high quality. Yani pounced on the scene and shouted at the top of her voice for her father to get her paper, brush and ink. In a few minutes she drew a monkey holding a jug of wine, smelling it greedily. The painting was given the title "It smells nice."

A few days afterwards, Yani saw some other uncles terribly drunk at a dinner party. To her young eyes this was indeed an interesting and funny scene. She could not help but want to put it into a drawing. She outlined three drunk monkeys, one of which was an elder monkey lying on the ground, dead drunk. Beside it, some wine was running out of the jug. "Dead Drunk" is the title of this painting.

Another painting depicts a baby monkey riding on the shoulders of a big monkey, who is walking proudly with his chest out. "The big monkey is my Dad." Yani told me seriously.

"But who's the baby monkey, then?" I asked. Pointing to her own nose, Yani smiled

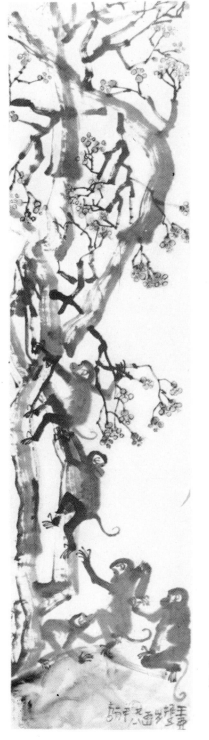

contentedly. That's true, she likes to go out on the streets riding on her father's shoulders.

In a word, monkeys have enriched the life of Yani and have, in turn, been enriched by her paintings.

Yani Is Brighter and Lovelier Than Monkeys

Yani could now present different kinds of monkeys on paper quite skilfully and smoothly. But one day, she suddenly declared to her father that she didn't like Lida any more. "She is not as bright or lovely as my monkeys," she said.

"Come on and pick them."
33cm × 132cm at five.

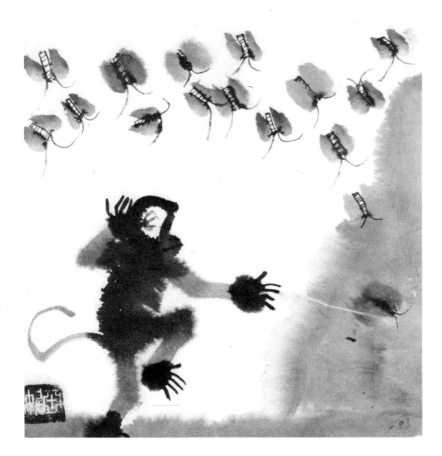

As a matter of fact, anyone who has ever seen Yani's paintings will agree. Yet, clearly enough, the one who's brighter and smarter than monkeys is Yani herself.

Yani's young mind is full of beautiful images. On rainy or cloudy days, when she is at home, she often tells her father that she wants to paint a picture to mail to the sun, for she blames the sun for its laziness. "It is always reluctant to leave its cozy quilt," she says. "What is more, it smears the sky black soon after it gets up." It happens that the house she lives in is low and that the sunshine, therefore, arrives through the window rather late in the morning. When she has breakfast, the kitchen windows are quite dark, and she thinks the sun makes it so.

Brimming with liveliness, enthusiasm and rich imagination, the monkey pictures

Yani creates are products of her own fancies. "Fruit Is Ripe" is the title of a picture that portrays two monkeys in a tree with three others under it. According to Yani, one monkey in the tree is picking fruit and another is asking, "Is it ripe yet?" "Yes, yes, it smells so sweet." "Then, come on and get it," the fourth and fifth monkeys cry eagerly.

Most of Yani's paintings require no interpretation, for the titles she gives them show their content. A picture of a baby monkey riding on a long-legged crane, who is walking towards a tall tree laden with fruit, is entitled "Picking Fruit."

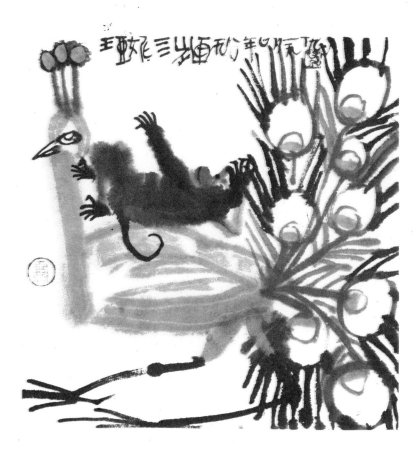

Another picture depicts a scene in which the moon is hanging in a vast sky and a peacock is swaying its beautiful tail, while a monkey stands on the back of a crane looking at the peacock's tail. For this, Yani just lets viewers imagine how the naughty monkey had earlier run up the peacock's tail to pick the moon.

In the picture "See If the Moon Is in the Water", we find a full moon hanging in the clear sky over an expanse of limpid water. There is a huge stone by the water on which an elder monkey is lying. A baby monkey bends over the elder one, his eyes wide open.

Spring is also the subject of some of Yani's paintings. One depicts butterflies buzzing around monkeys, who stand among blossoming flowers. Yani describes this as "Monkeys Go Visiting Butterflies".

With the intriguingly fluent brush strokes, bold and imag-

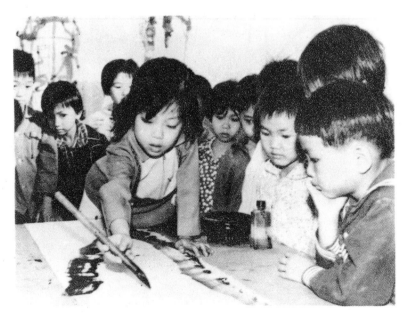

Yani painting impromptu for young enthusiasts (at six).

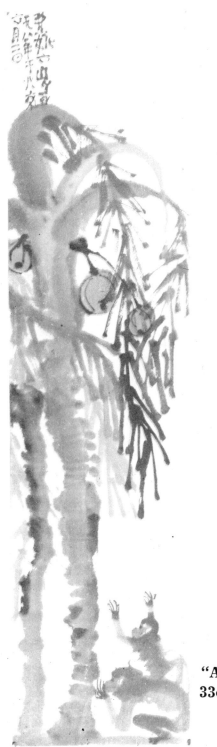

inative composition and life-like characters, Yani's paintings bring us into a splendid fairyland. The monkeys are the various characters in that fairyland. No wonder she said, "My monkeys are far brighter and lovelier than Lida."

How Yani developed her ability to paint can be summed up as follows: Images inspire her feelings; feelings enrich the characters and images she creates; and finally her fancies liberate her from the images. This, in my opinion, is also the source of the great artistic creativeness and romanticism.

It is generally believed that successful artists are never too old to learn. But, as far as I am concerned, they should also

"A Strange Tree."
33cm × 132cm at six.

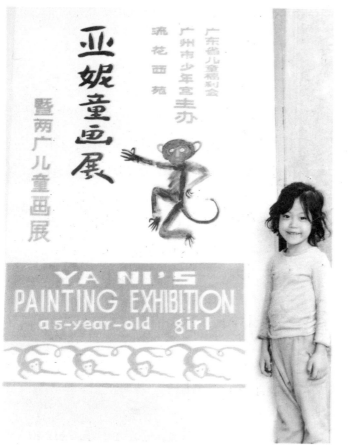

亚妮童画展

暨两广儿童画展

广东省儿童福利会
广州市少年宫主办
流花西苑

YA NI'S
PAINTING EXHIBITION
a 5-year-old girl

Yani's painting exhibition in Guangzhou (at five).

play, because only in play can an artist's reservoir of enthusiasm and imagination be freely revealed. An imaginative artist should remain as naive as a child, allowing his imagination to go as far as possible in the realm of art. This being so, there is no reason why we shouldn't permit children to develop their ingenuity by themselves.

Here I need to make it clear that I'm neither a naturalist, standing for a laissez-faire attitude towards children, nor an advocate of the theory of innate genius. If a person is born with a gift for art, then this needs development. Of course, not every child is intelligent, but every child is imaginative. Yet the more intelligent have more active minds than the less intelligent. It is only right that adults should guide children's feel-

ings with reason, or it may spoil their imaginations, and even the most gifted child may become mediocre.

This truth is lived out by Yani's father. Having discovered his daughter's interest in painting, he, instead of teaching her by guiding her hand, often plays with her and offers her a brush, large sheets of paper and monkeys, all for the purpose of letting her develop her imagination through images. For children have their own logics. The development of their talent also requires time.

From the first, the trees in Yani's paintings had no leaves. Yani's father often took her to see fruit trees in the park, or brought pots of brightly coloured flowers home, in order to turn her attention to the leaves.

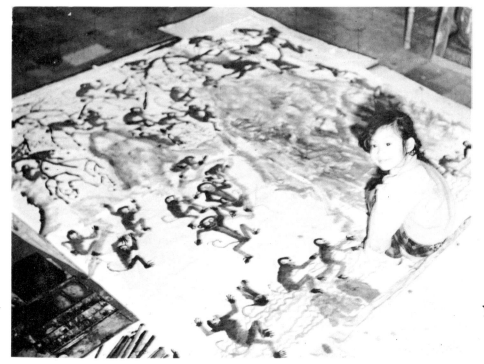

Yani at five.

However, these efforts failed. At last, he had asked her why. "They arc not good to cat." She replied with perfect assurance, speaking, as always, in terms of the monkeys.

Not long ago, leaves began to appear on one of her paintings. The sight was strange since fruit was on the tip of every leaf. "Why did she make it that way?" I wondered. "Well, the leaves are feeding the fruit," was her answer. Later on, I was informed that a botanist had come to visit her family, and told her about the photosynthesis of leaves and how leaves nourished plants. From this Yani derived the inspiration to make this painting. Since fruit is the food for monkeys, there must be something to nourish the fruit, too. Isn't that logical?

Once Yani painted a tree that bears two different fruits. "What kind of tree is this?" asked her father. "It's called 'A Strange Tree'," said Yani. Yani's father now understands. She has put two of her favourite kinds of fruit on the same tree. Why correct her? Isn't that the way human beings remake the world of plants?

Now open this painting album of Yani's work and you will find yourself in the world of children, so that you may be able to understand them better. Herein you will also find something more splendid than realit·

HUANG QINGYUN
Vice-President of the Guangdong Branch of the Writers' Union
1982

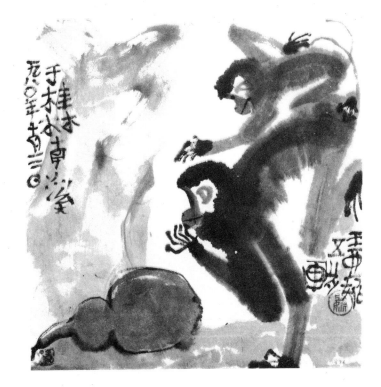

Yani's Monkeys

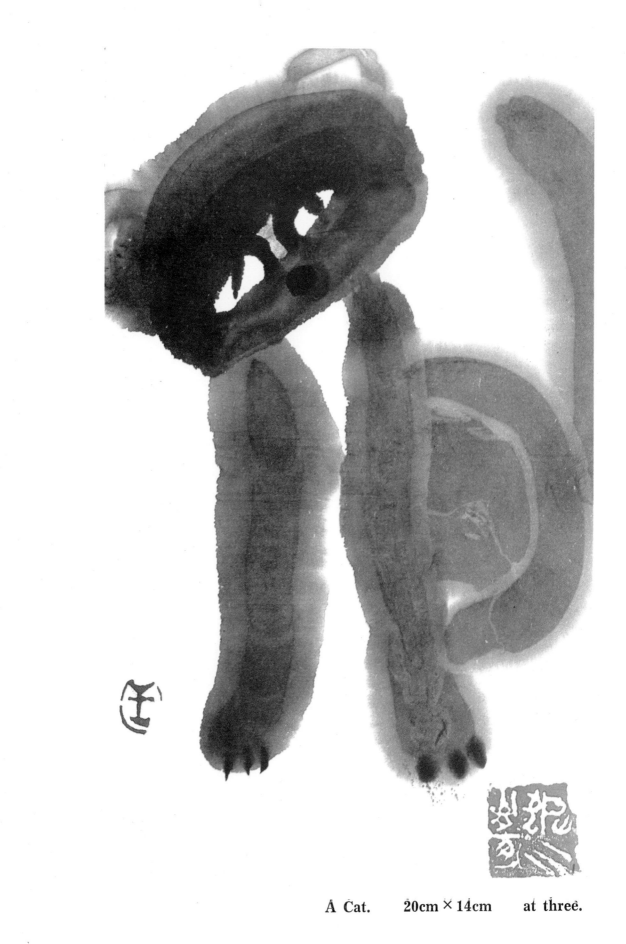

A Cat.　　20cm×14cm　　at three.

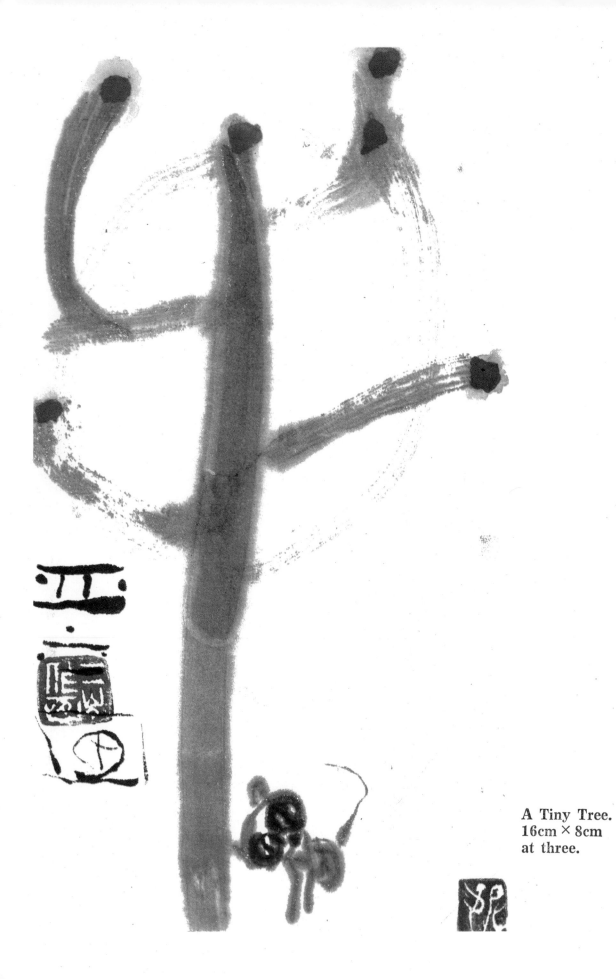

A Tiny Tree.
16cm × 8cm
at three.

Juicy Fruit for the Baby Monkey.
60cm × 65cm at three.

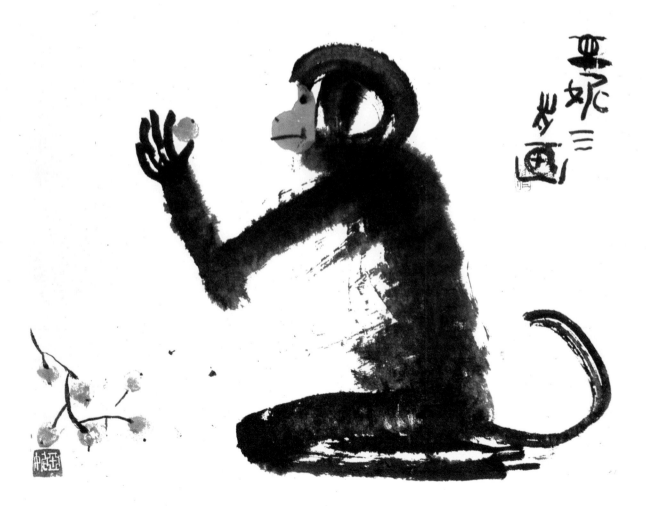

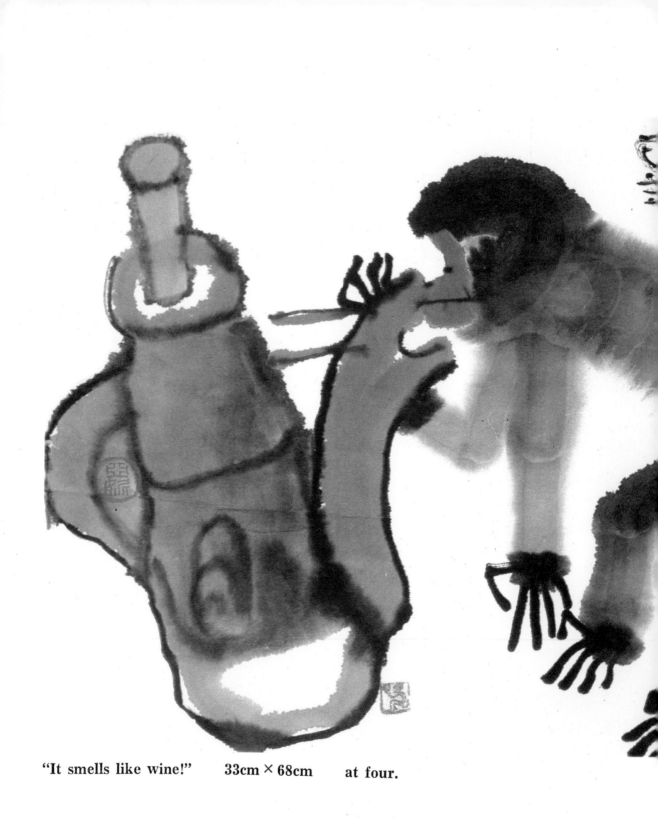

"It smells like wine!" 33cm × 68cm at four.

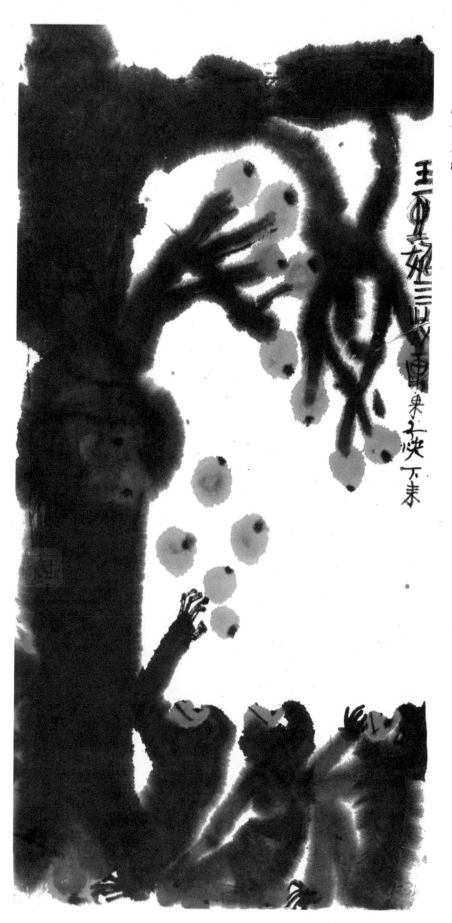

Their Mouths
Watering.
33cm × 68cm
at four.

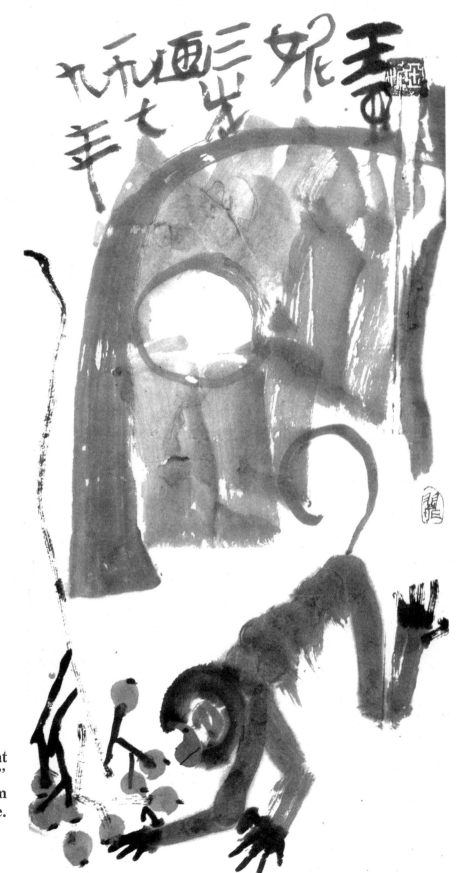

"That's just what
he wants."
33cm × 68cm
at three.

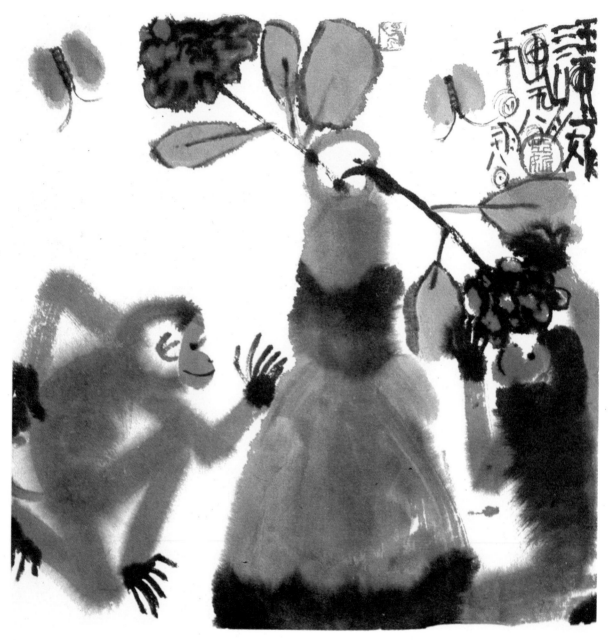

"What a nice smell!" 33cm × 34cm at four.

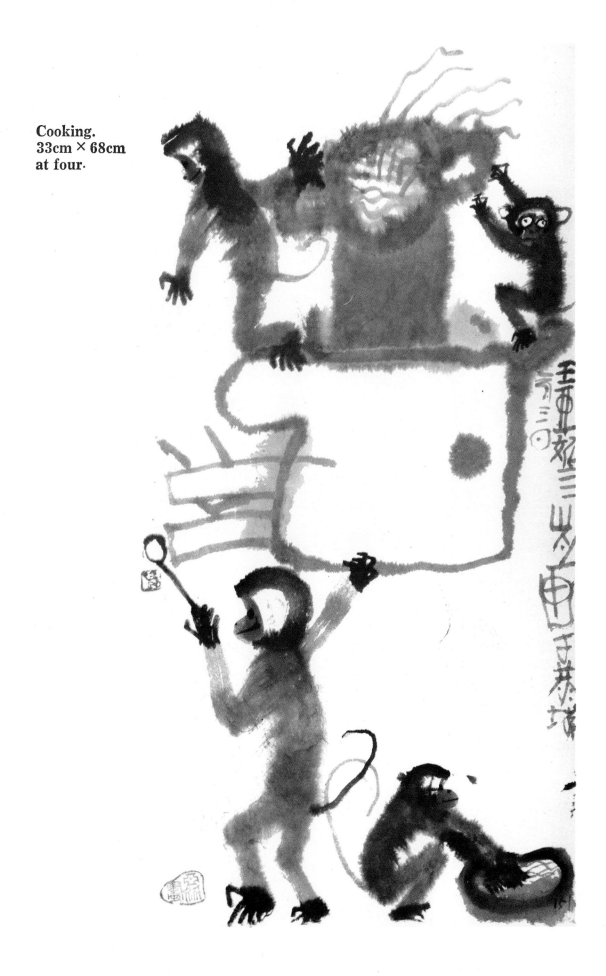

Cooking.
33cm × 68cm
at four.

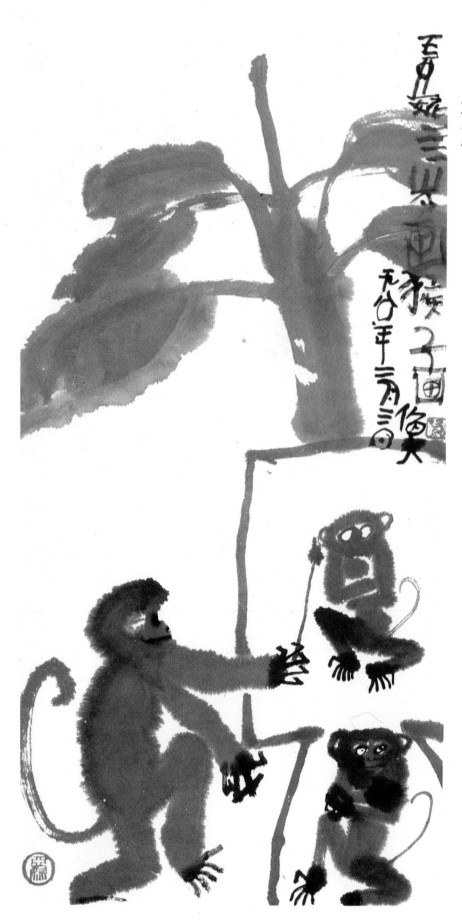

Drawing a Portrait.
33cm × 68cm
at four.

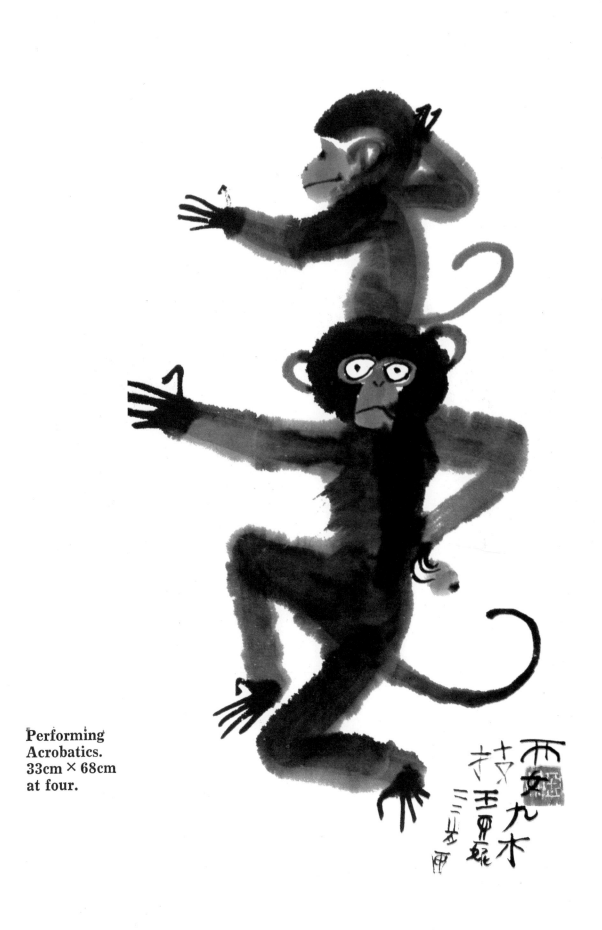

Performing
Acrobatics.
33cm × 68cm
at four.

Dead Drunk. 33cm × 68cm at five.

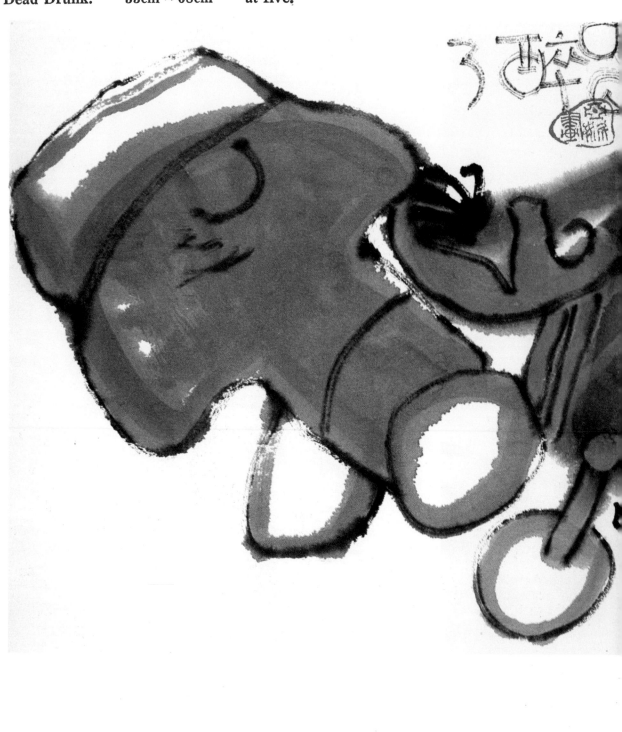

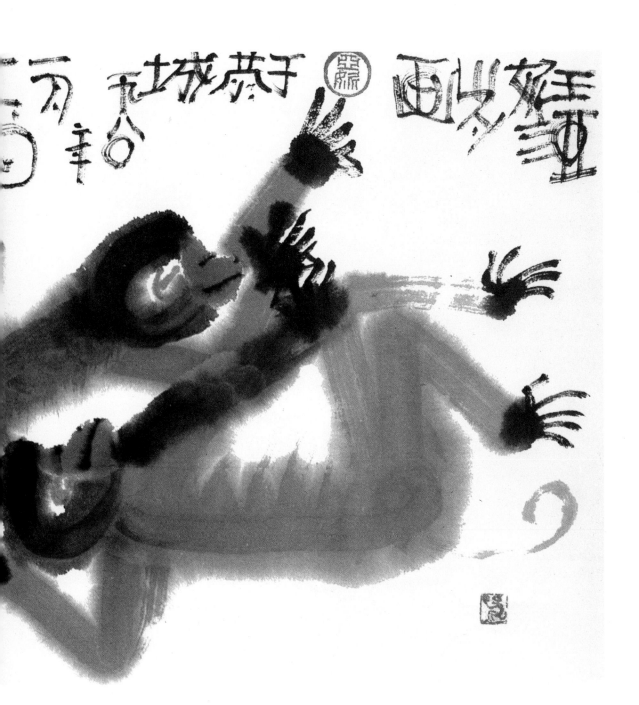

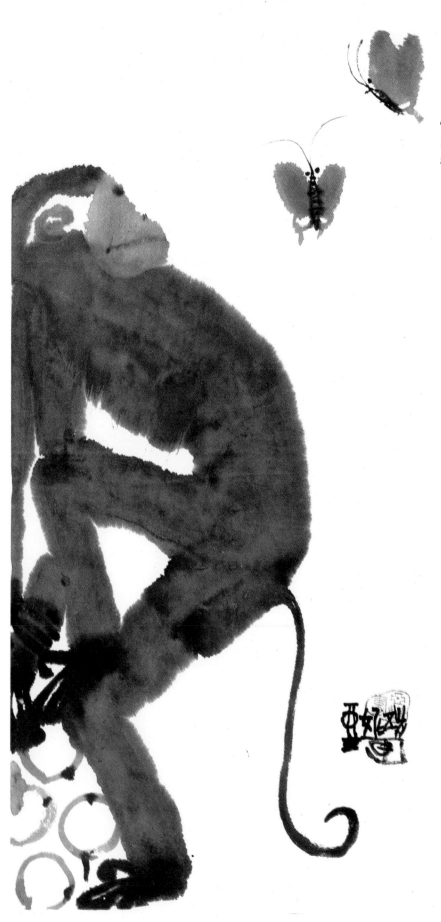

"That's all mine."
33cm × 68cm
at four.

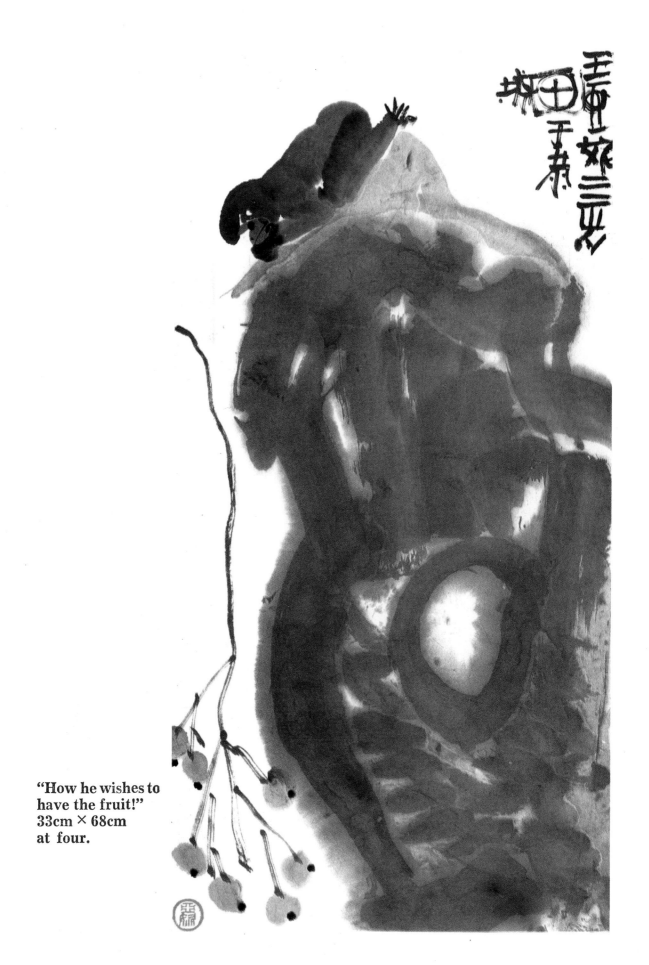

"How he wishes to
have the fruit!"
33cm × 68cm
at four.

Feeding the Peacock. 33cm × 34cm at four.

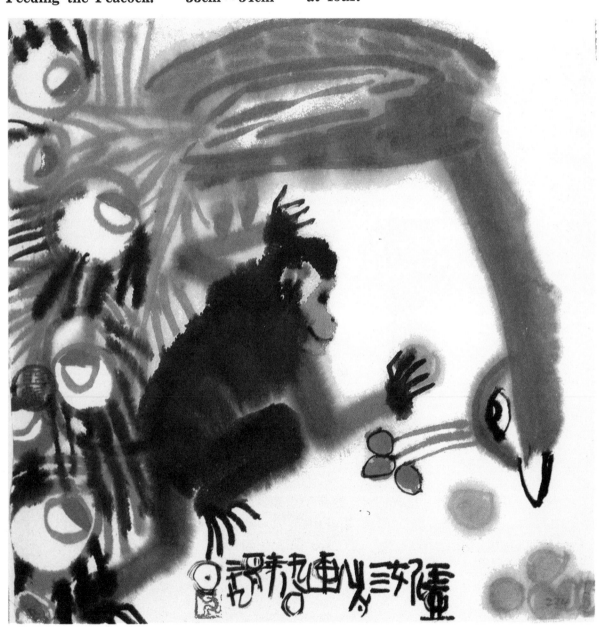

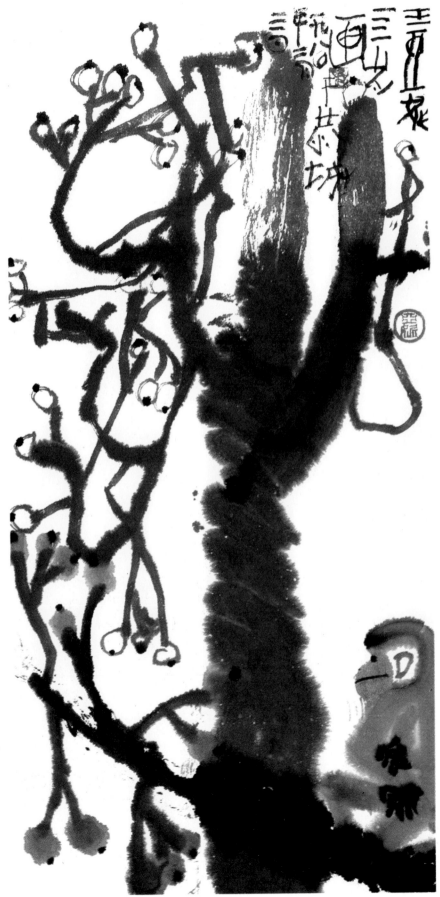

"How anxious his
eyes are!"
33cm × 68cm
at four.

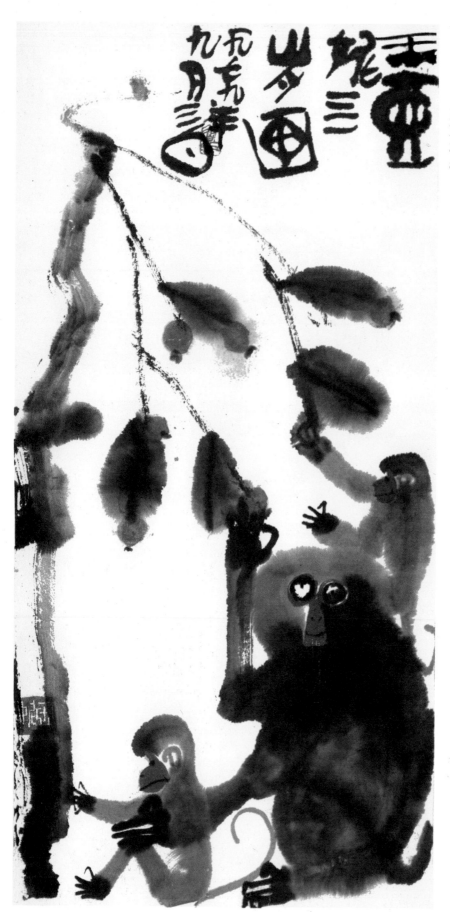

Picking Delicious
Fruit.
33cm × 68cm
at four.

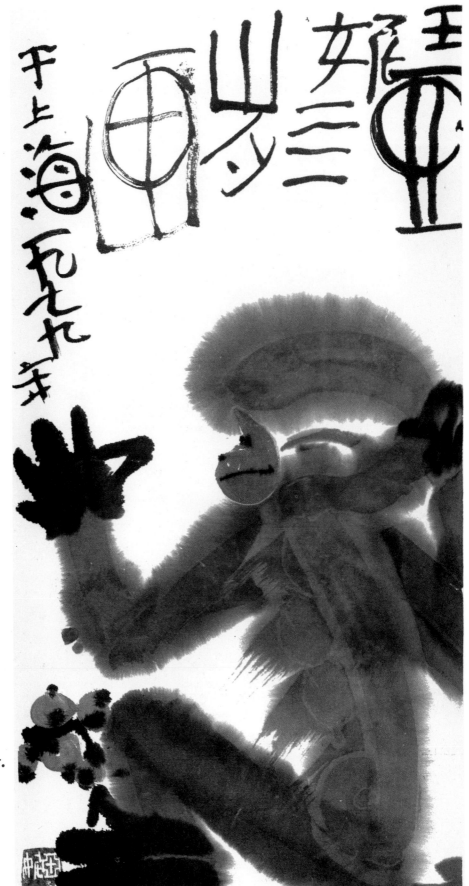

A Baby Monkey.
33cm × 68cm
at four.

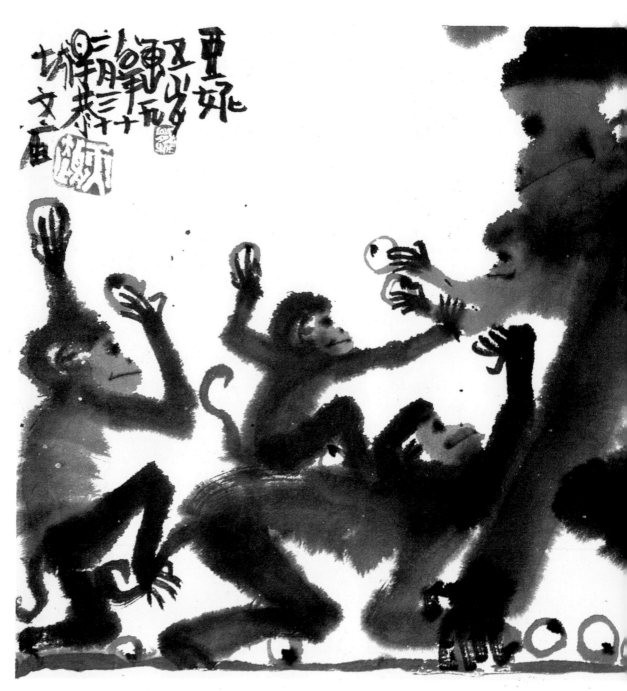

Mother Monkey and Her Children. 33cm × 68cm at four.

Fetching Water. 33cm × 34cm at five.

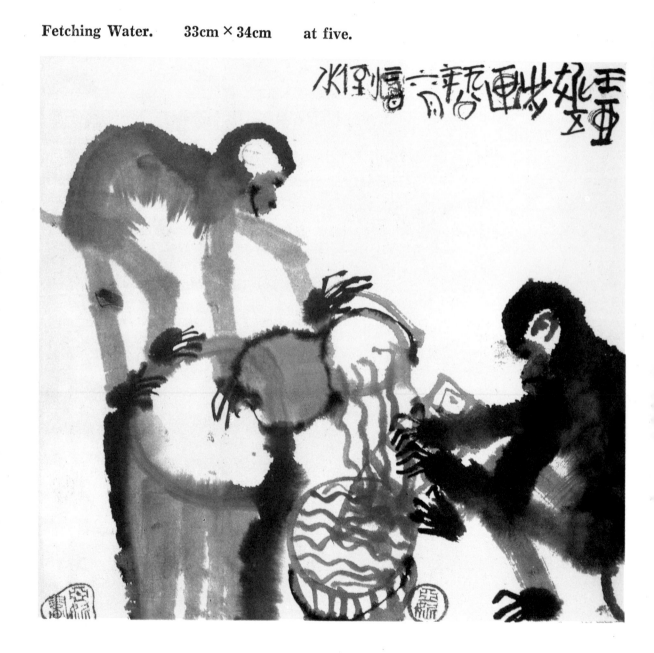

Searching for More Fruit.　　33cm ×34cm　　at five.

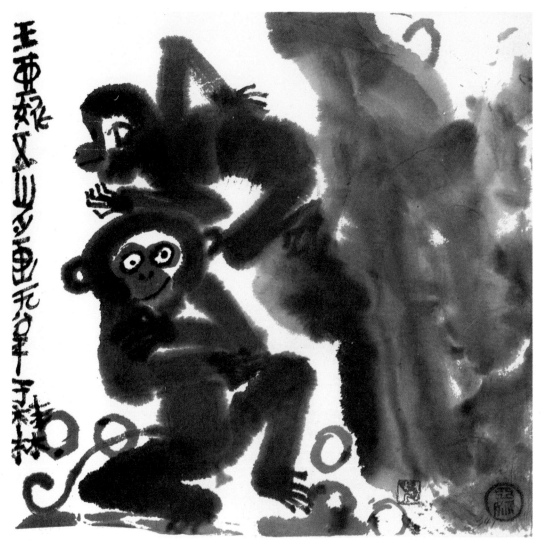

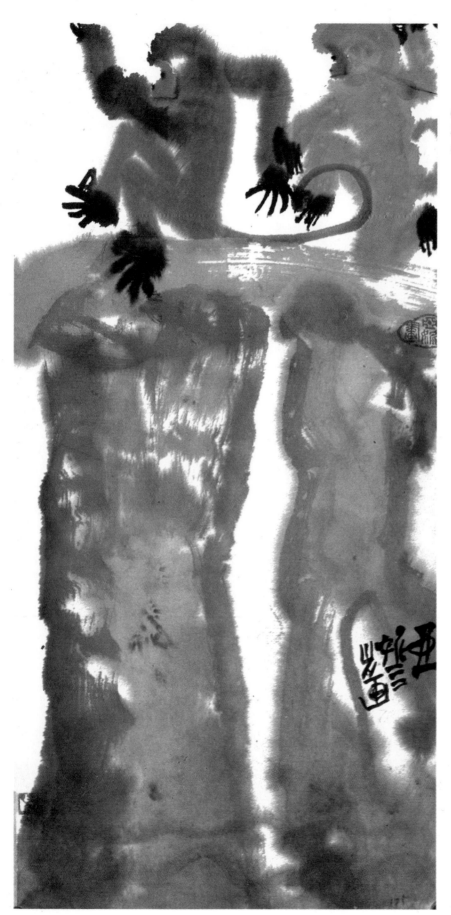

Crossing the Bridge.
33cm × 68cm
at four.

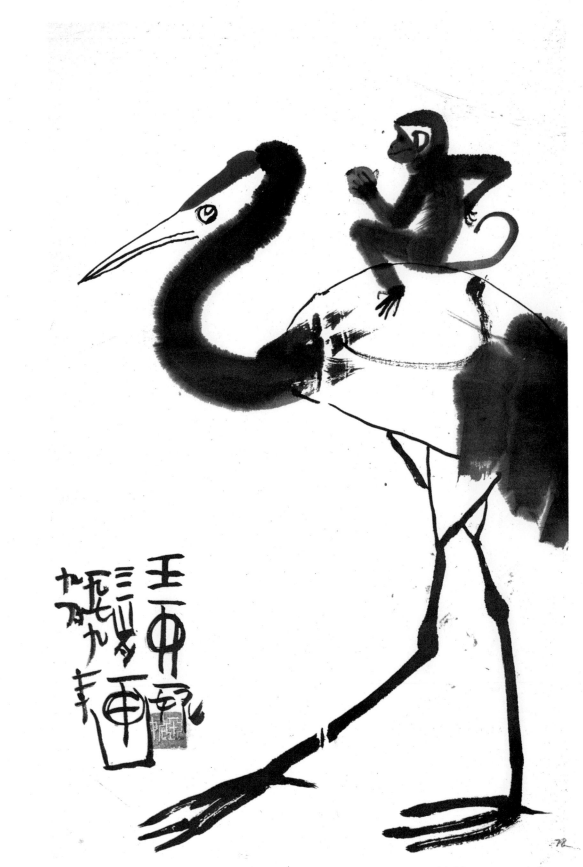

Riding on a Crane. **40cm × 60cm** **at four.**

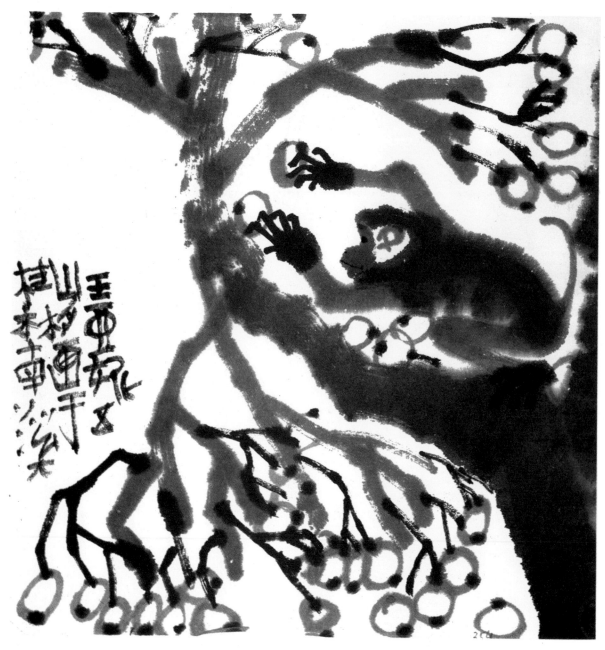

"That is just what he is after."
33cm × 34cm at five.

Looking at the Moon in the
Water. 33cm × 132cm
at four.

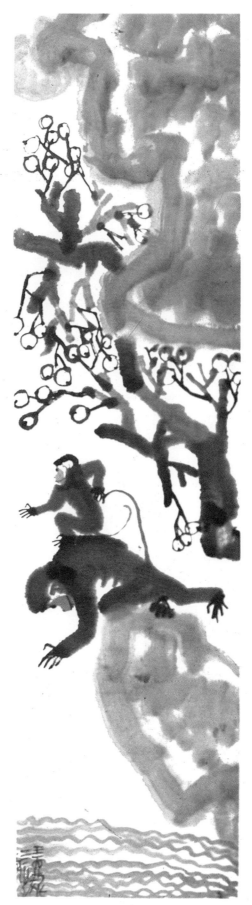

"How inviting the fruit is!" 33cm × 68cm at five.

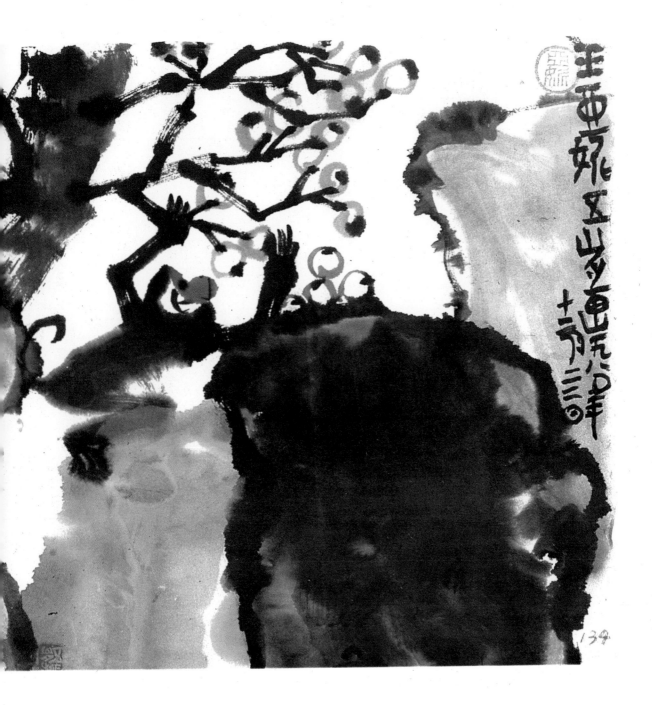

139

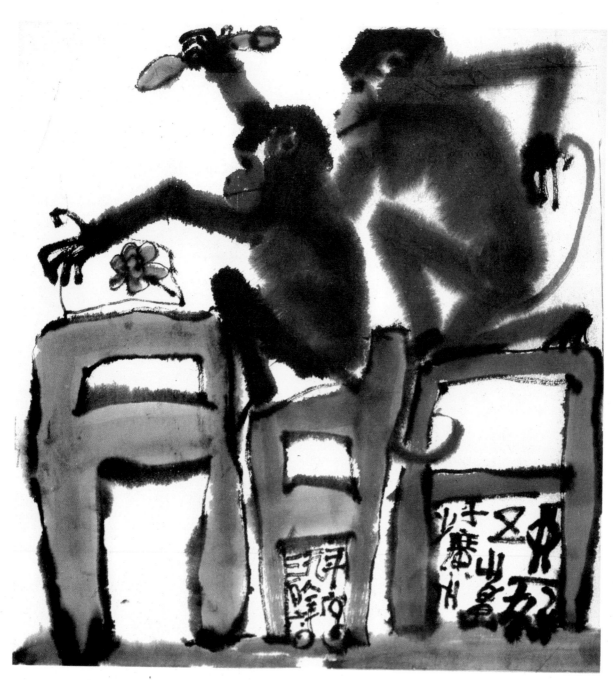

Drawing Flowers. 33cm × 34cm at five.

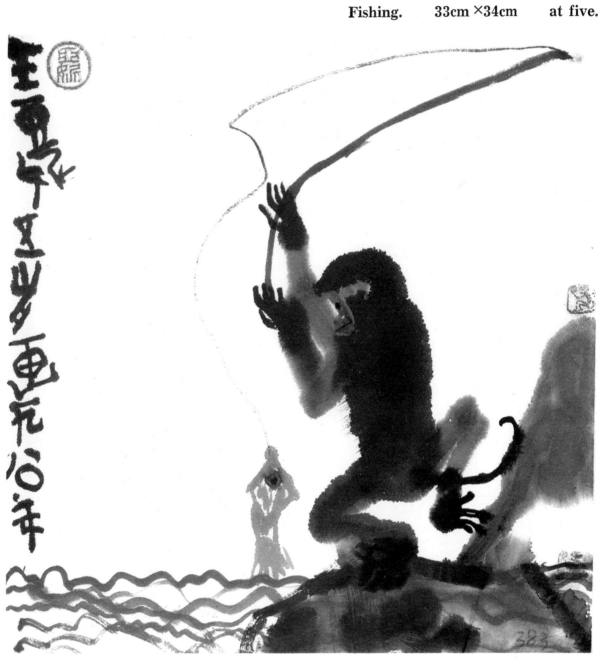

Fishing.　　33cm ×34cm　　at five.

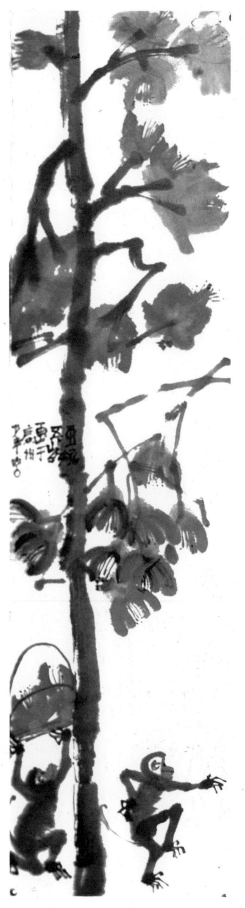

Kapok in Bloom.
33cm × 34cm at five.

"That is for Mommy." 33cm × 34cm at five.

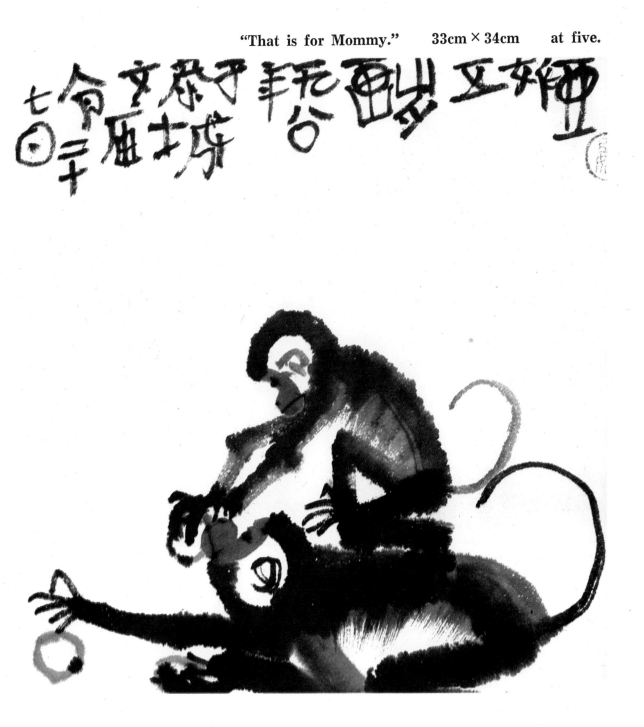

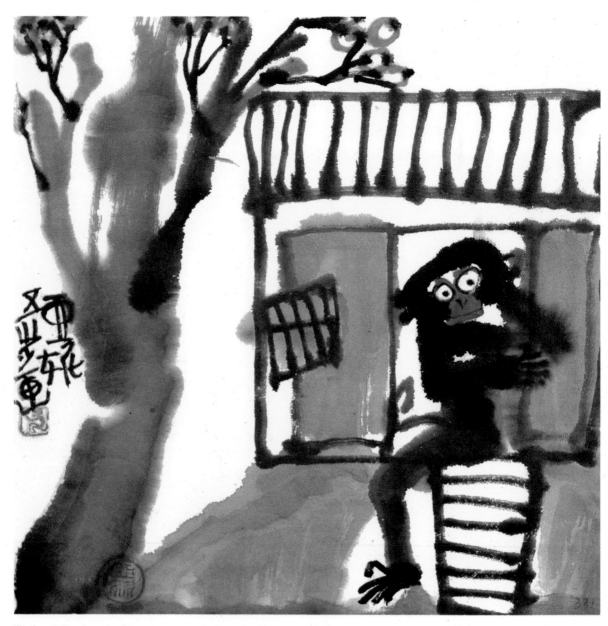

Baby Monkey's House. 33cm × 34cm at five.

New Year Festivity. 60cm × 65cm at five.

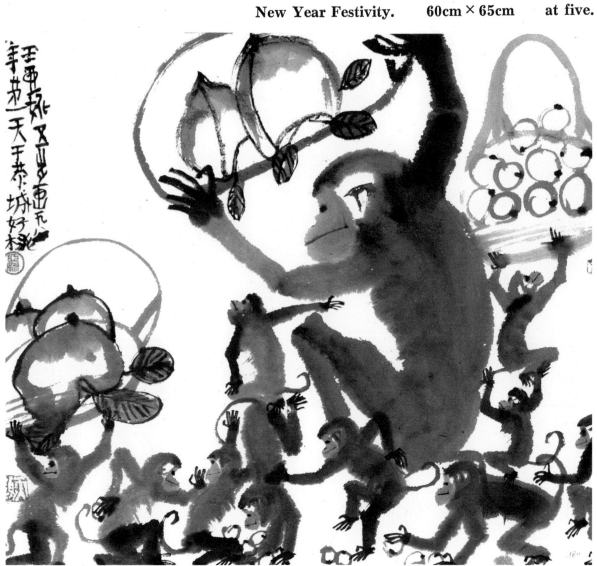

Monkeys Scrambling for Fallen Fruit. 68cm × 132cm at five.

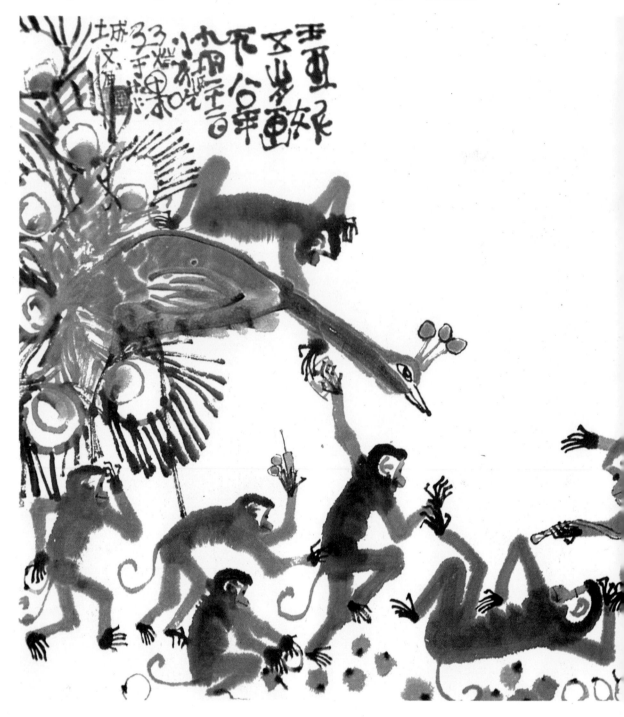

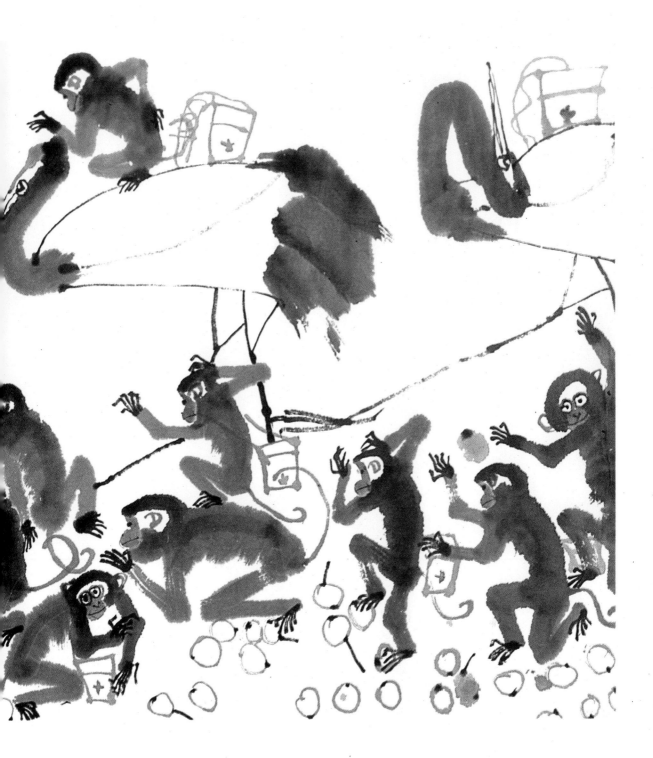

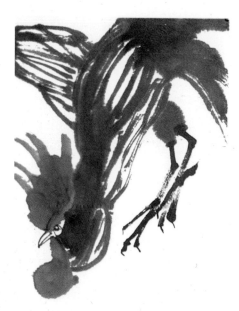

"The rice is for you."
33cm × 132cm at five.

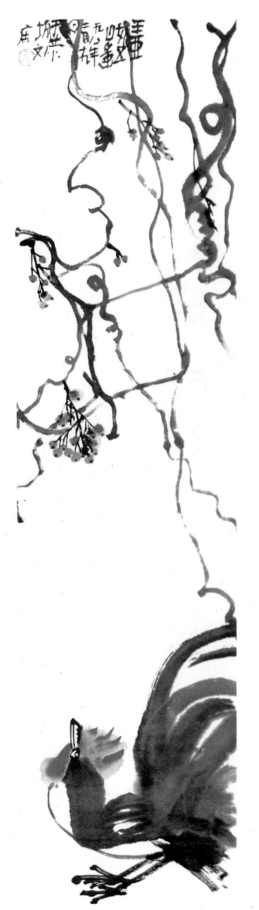

A Rooster Pecking at Grapes.
33cm × 132cm at five.

A Peacock and a Crane Whispering. 33cm × 34cm at five.

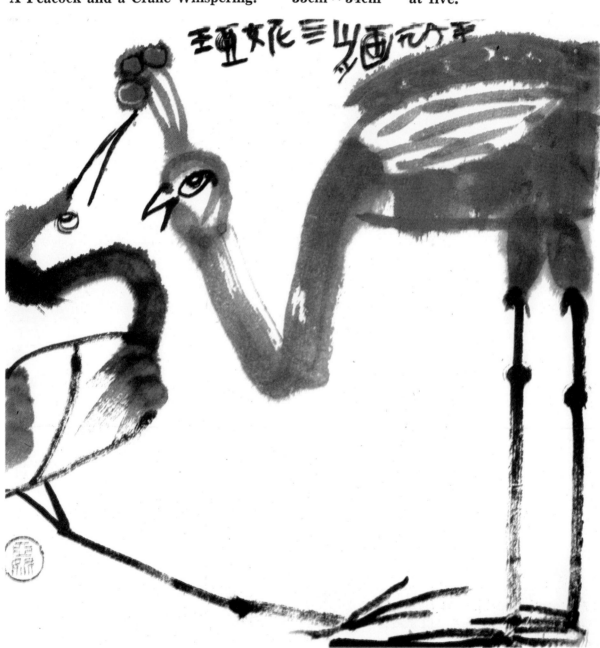

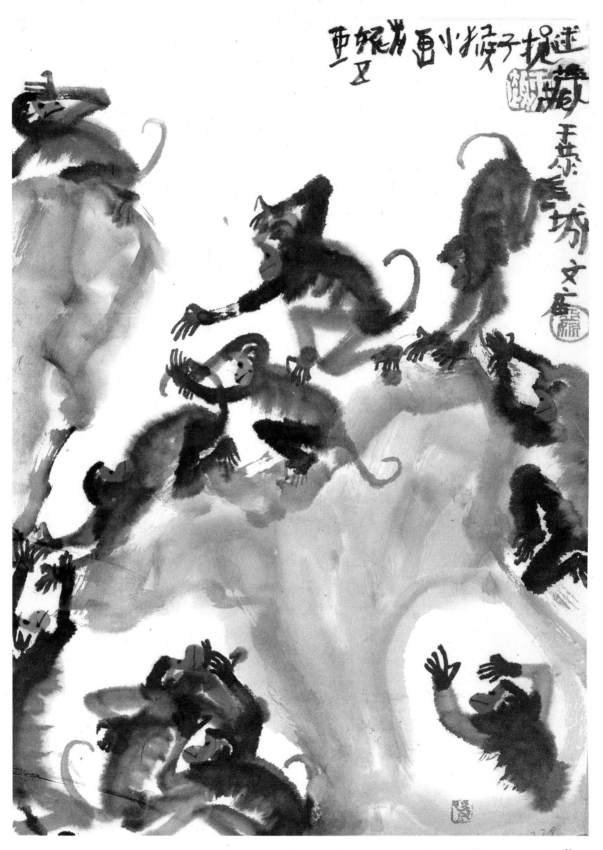

Playing Hide-and-Seek. 40cm × 60cm at five.

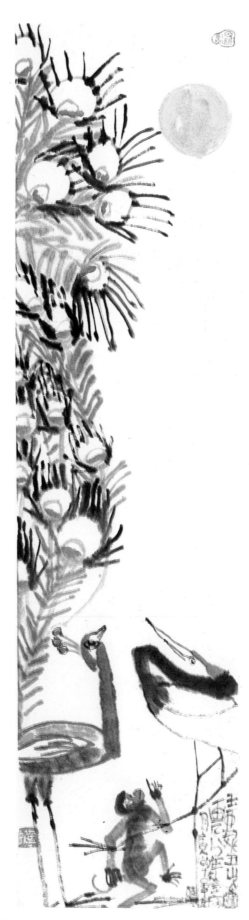

Story About the Moon.
33cm×132cm at five.

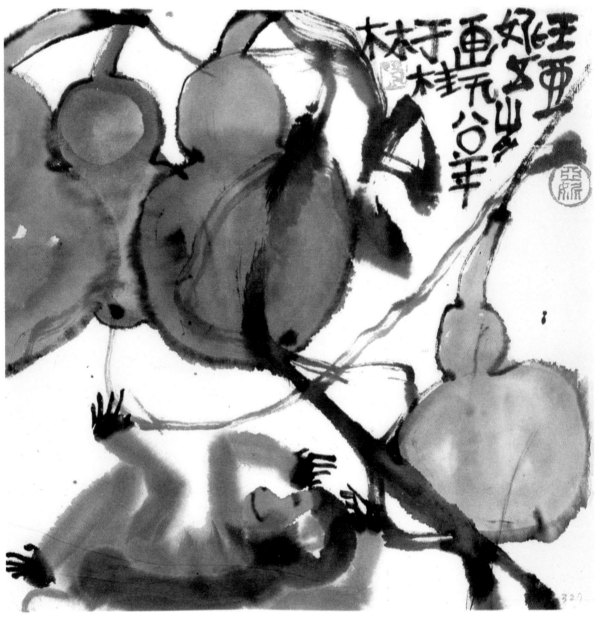

Sleeping Under the Gourd. 33cm × 34cm at five.

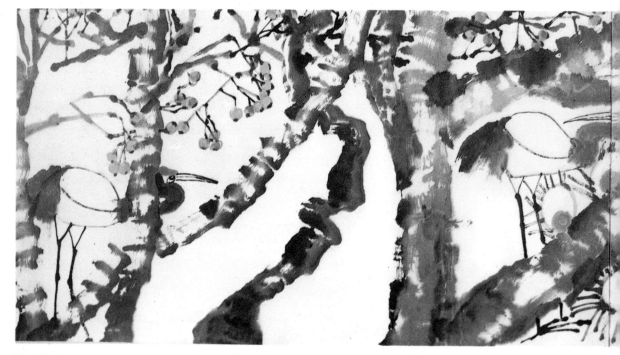

In the Forest. **68cm × 264cm** **at five.**

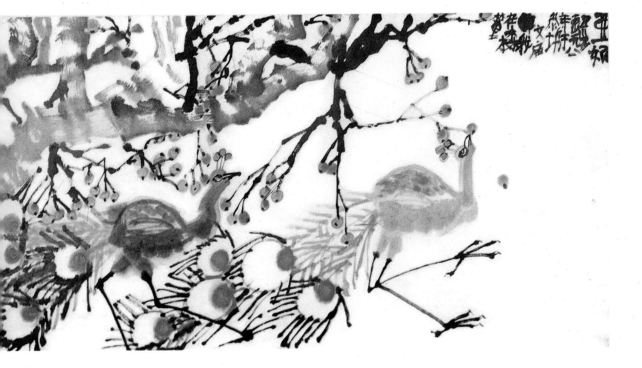

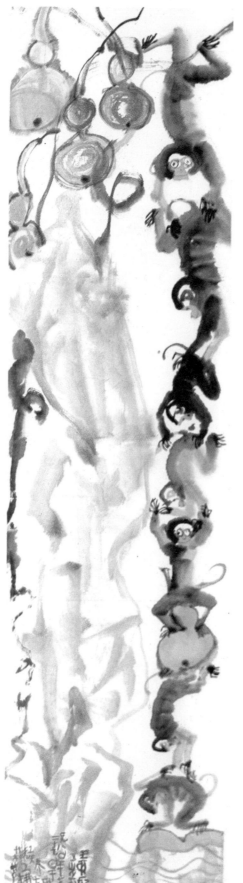

Fishing for the Gourd.
33cm × 132cm at five.

Washing Fruit.
33cm × 132cm at five.

Drawing a Tree.
33cm × 132cm at five.

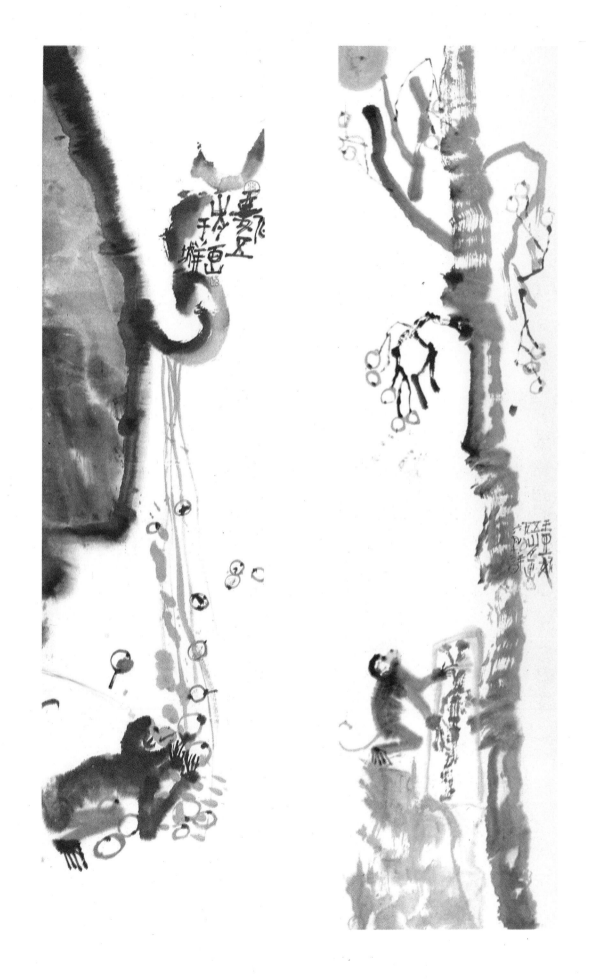

Giving a Shot. 33cm × 34cm at five.

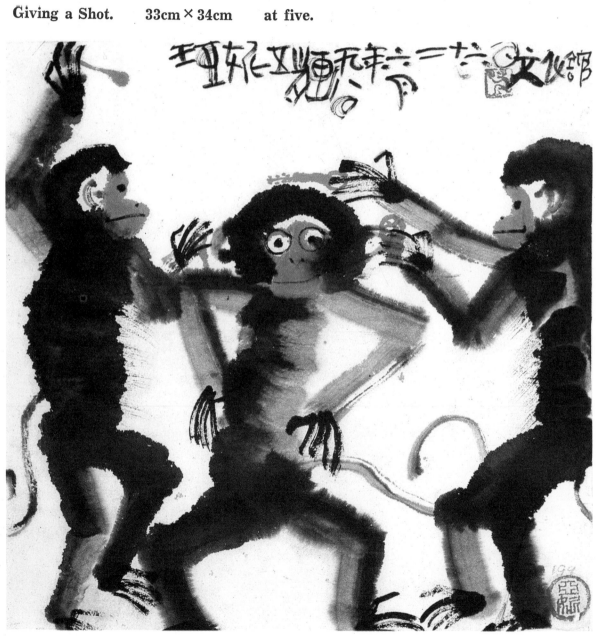

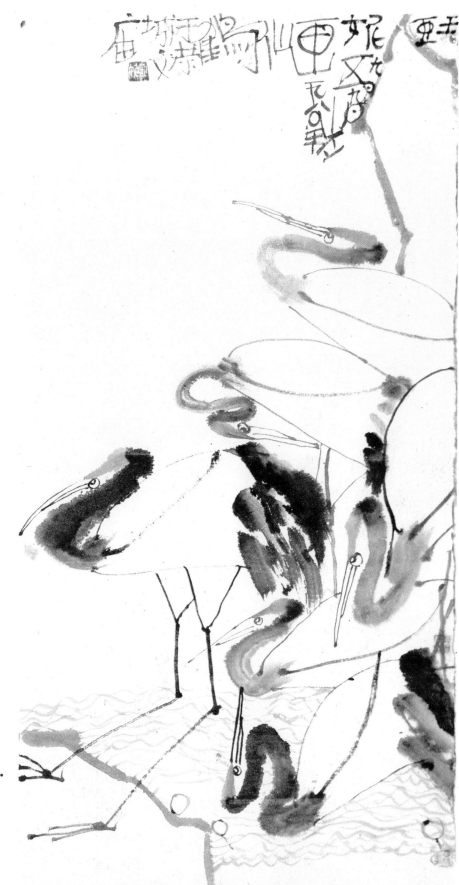

Beautiful Cranes.
68cm × 132cm
at five.

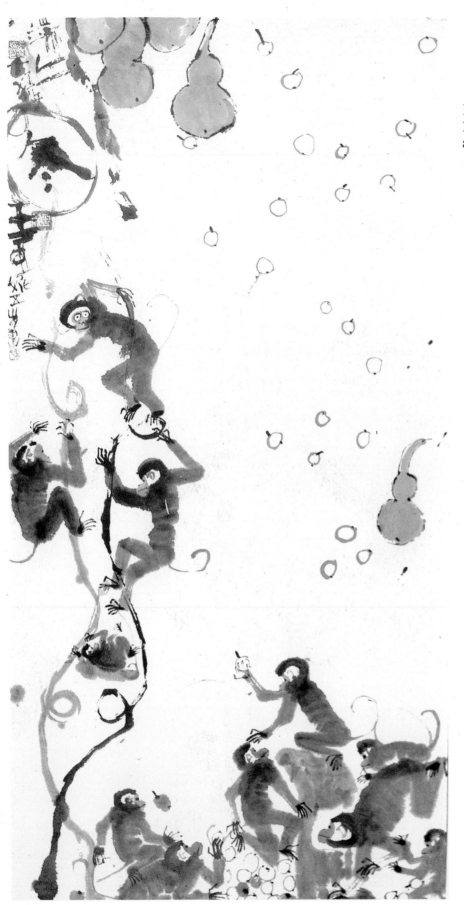

Lucky Windfalls.
132cm × 66cm
at five.

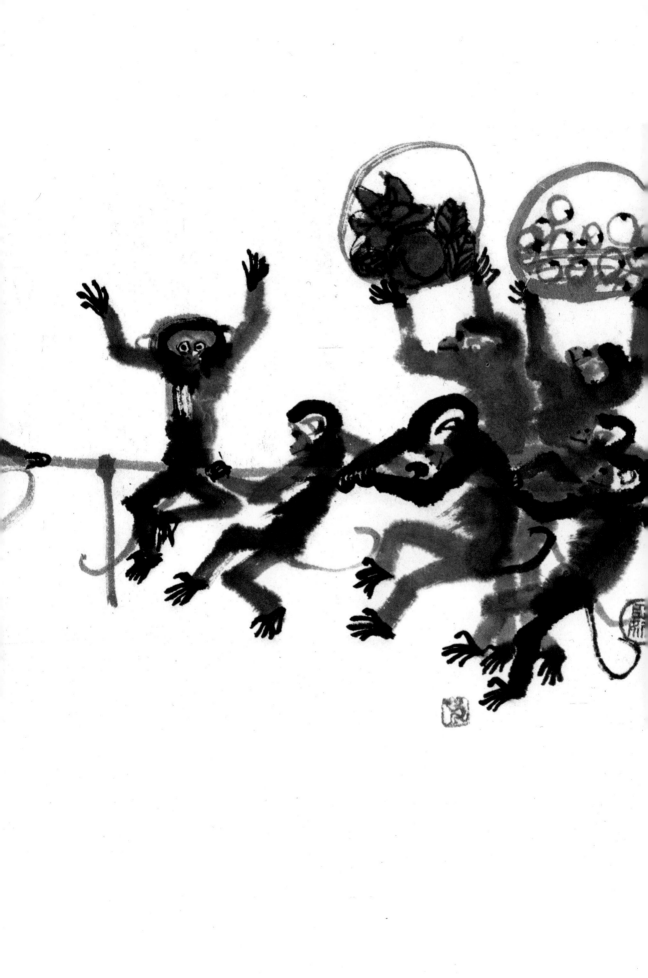

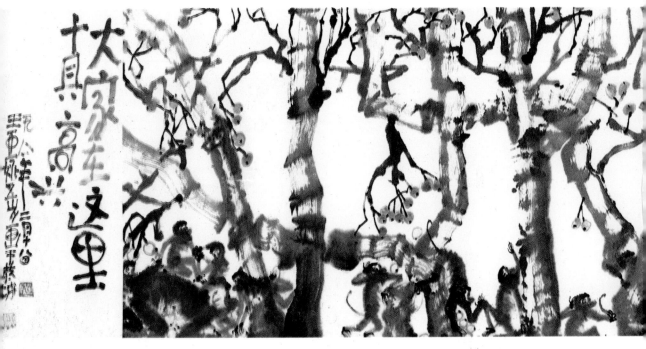

It is heaven to be in the orchard."　561cm × 68cm　　at five.

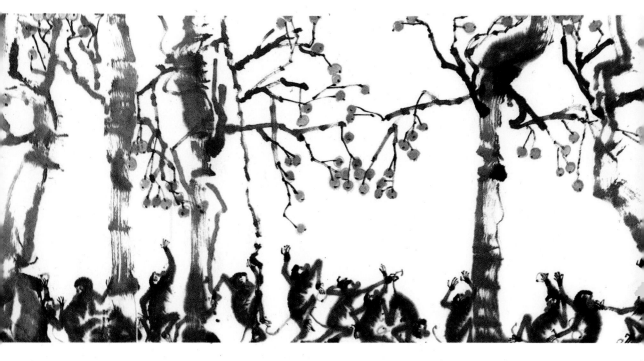

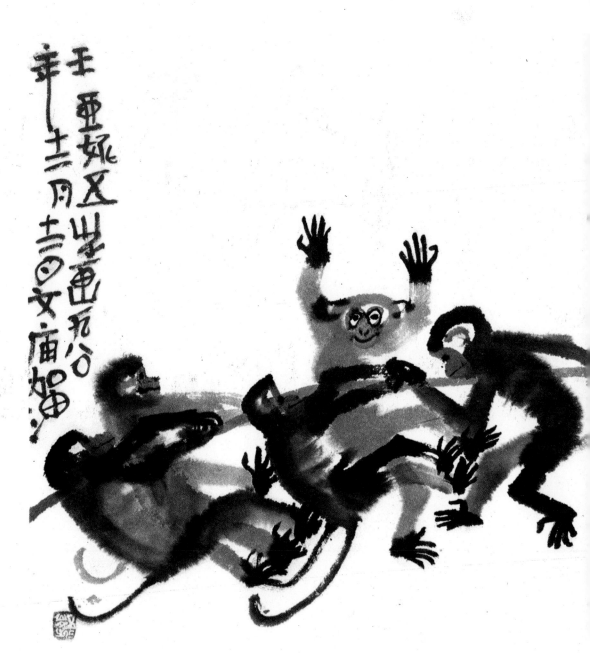

A Tug of War. 33cm × 132cm at five.

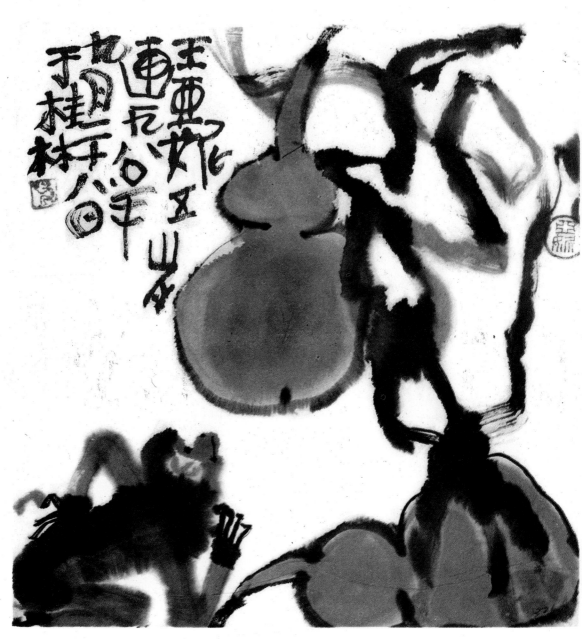

"What fun to look at the gourd!" 33cm × 34cm at five.

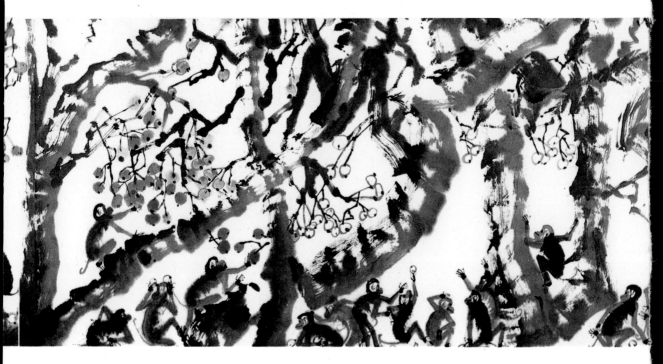

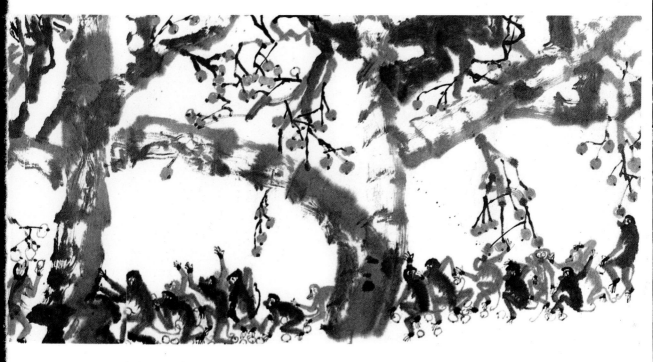

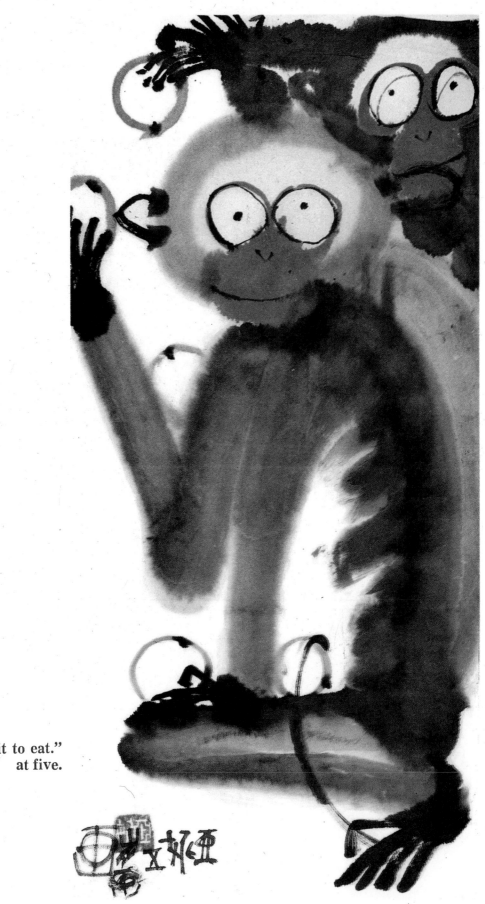

"We have fruit to eat."
cm × 68cm at five.

Playing Basketball. 33cm × 34cm at five.

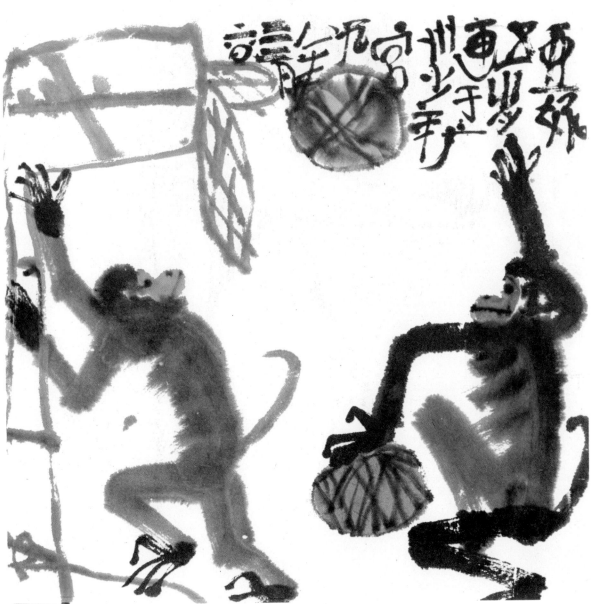

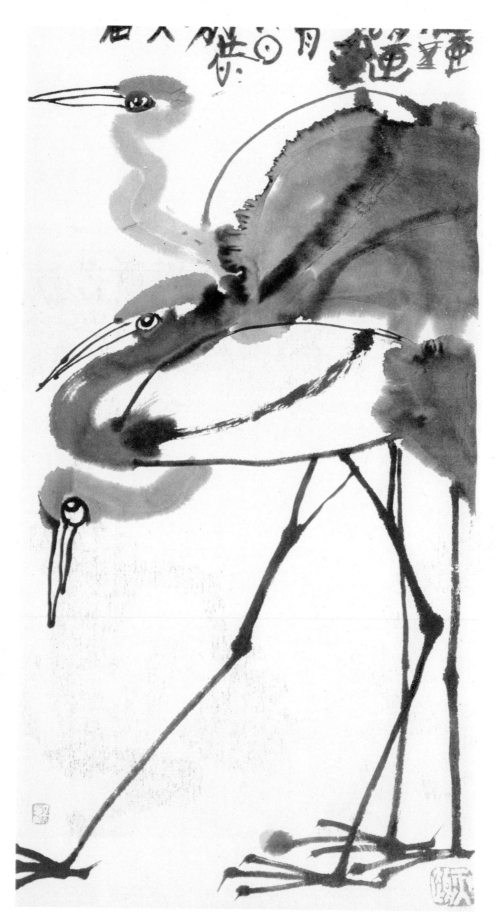

Three Cranes.
33cm × 68cm
at five.

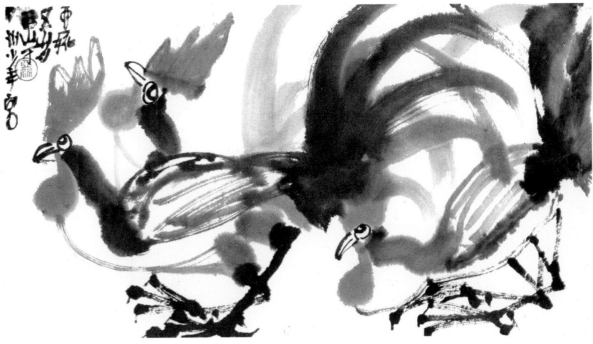

Three Roosters. 33cm × 68cm at five.

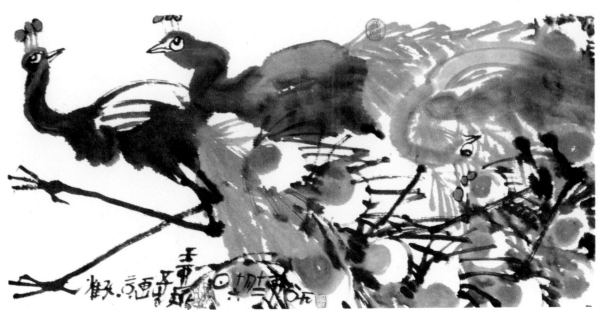

Three Peacocks. 33cm × 68cm at five.

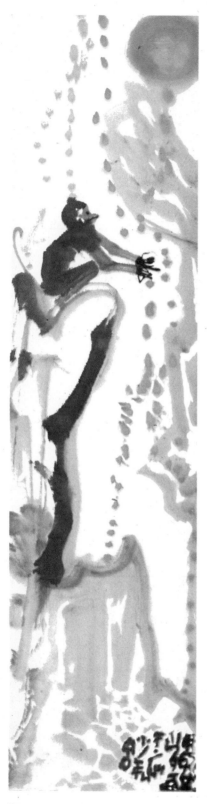

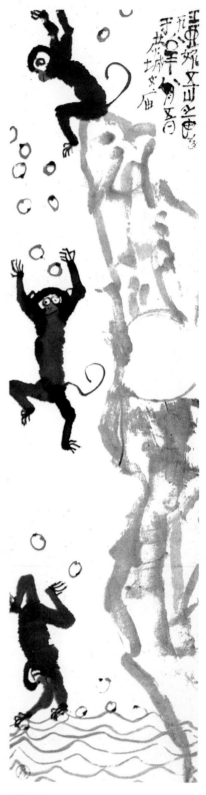

"Funny to be standing in rain
in the sunshine!"
33cm × 132cm at five.

Diving. 33cm × 132cm
at five.

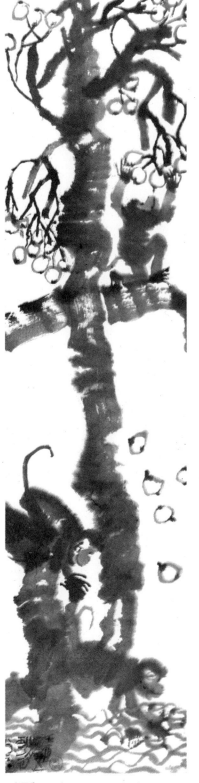

"The clearer, the better."
33cm × 132cm at five.

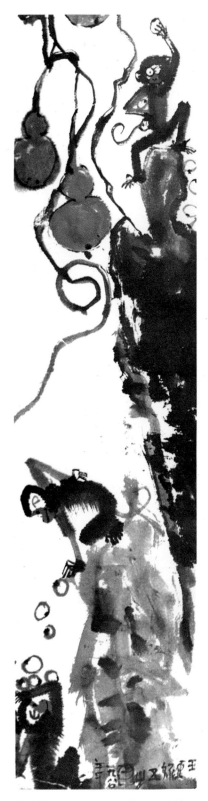

"What a treat to have all
this fruit."
33cm × 132cm at five.

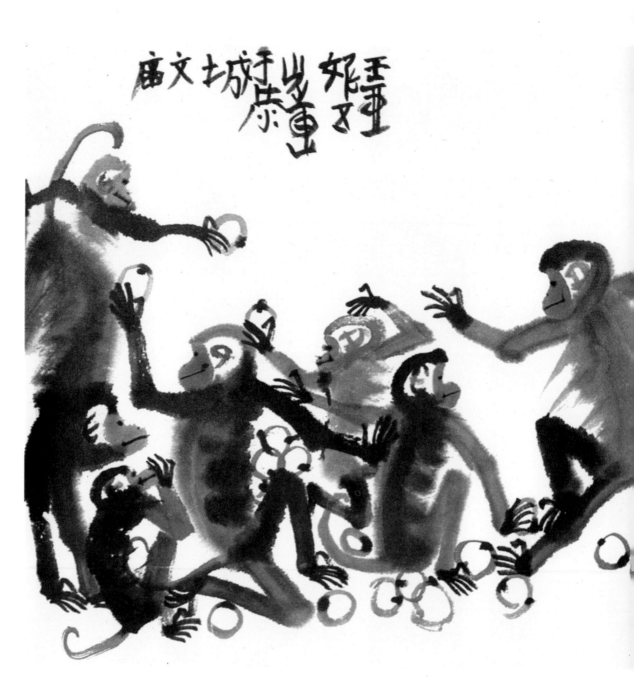

Dancing Happily. 66cm × 132cm at five.

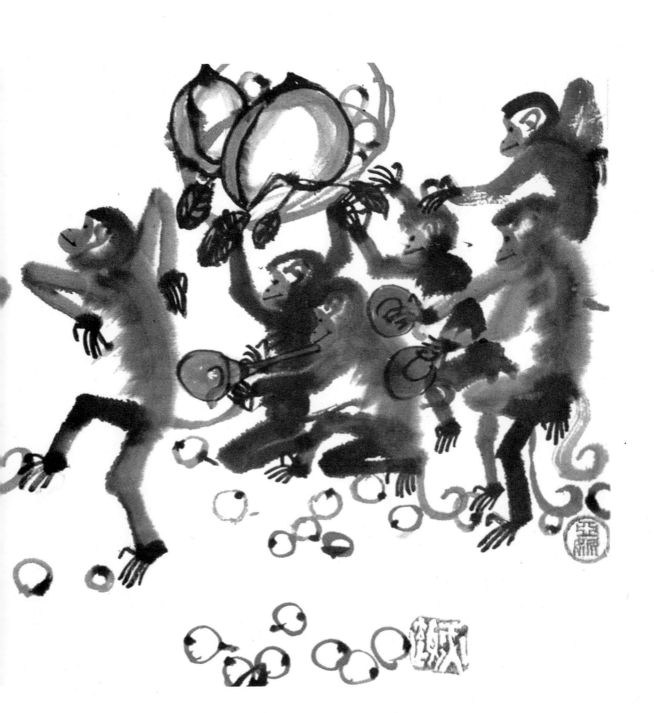

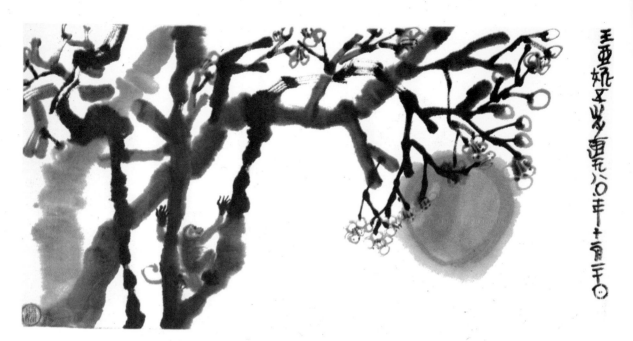

Gathering Plum Flowers.　　68cm × 132cm　　at five.

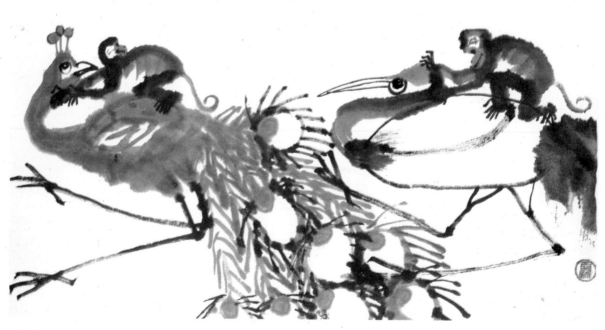

"The race is on."　　68cm × 132cm　　at five.

"Where have all the butterflies gone?"
32cm × 34cm at five.

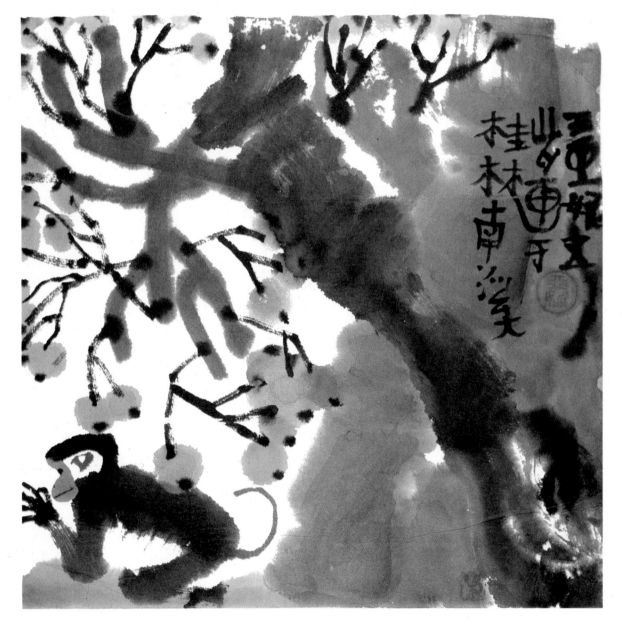

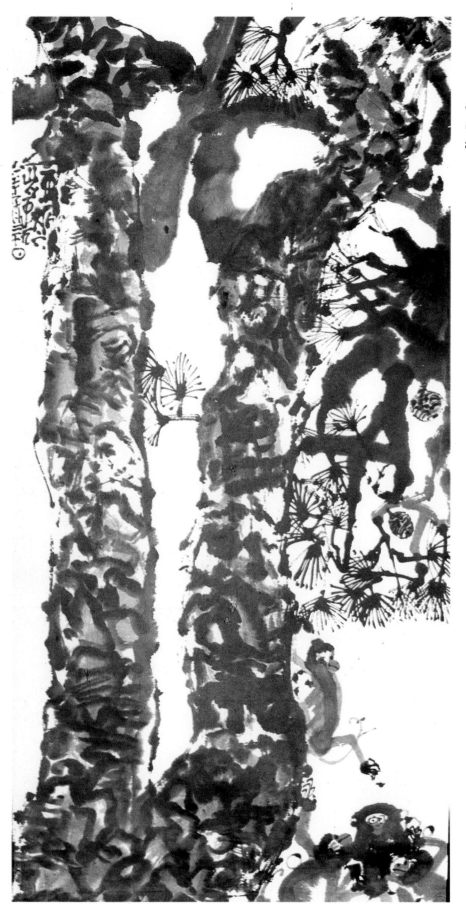

"I am an ace climber."
66cm × 132cm
at six.

"How invitingly nice
33cm × 132cm
at six.

Riding on a Dee
33cm × 132cm
at six.

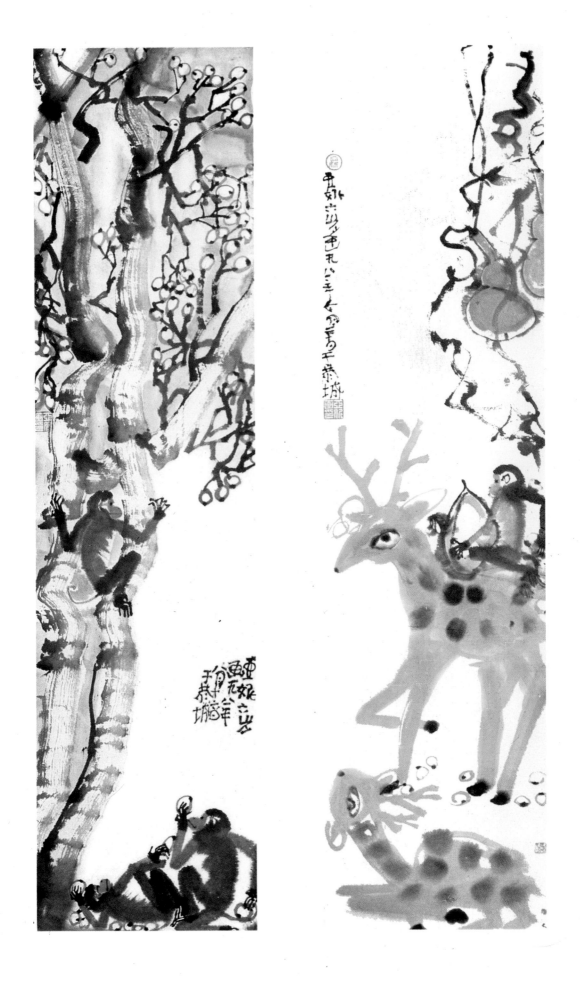

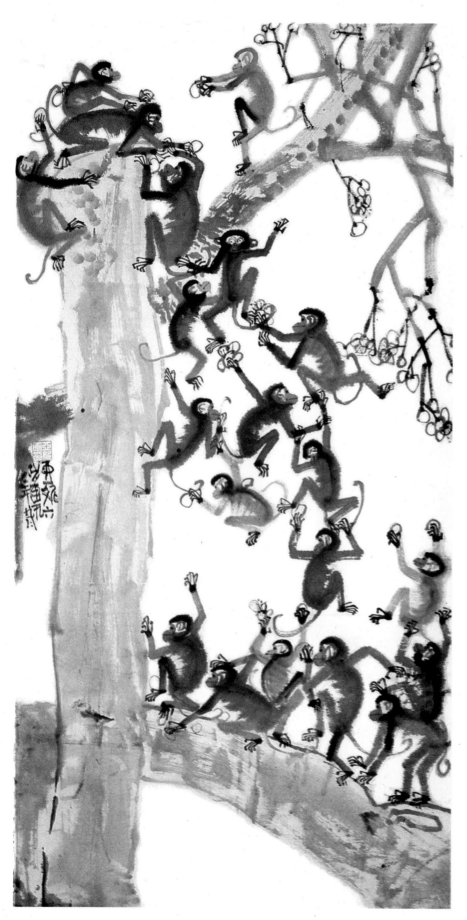

Playing a Game.
66cm × 132cm
at six.

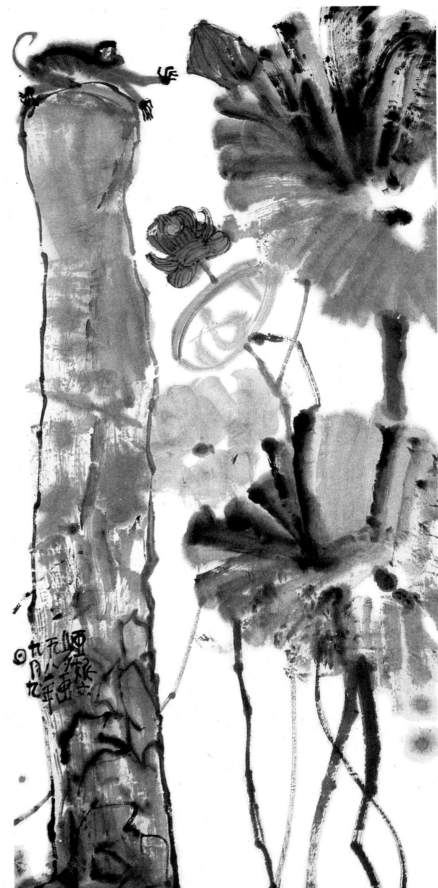

"What a beautiful
lotus flower!"
66cm × 132cm
at six.

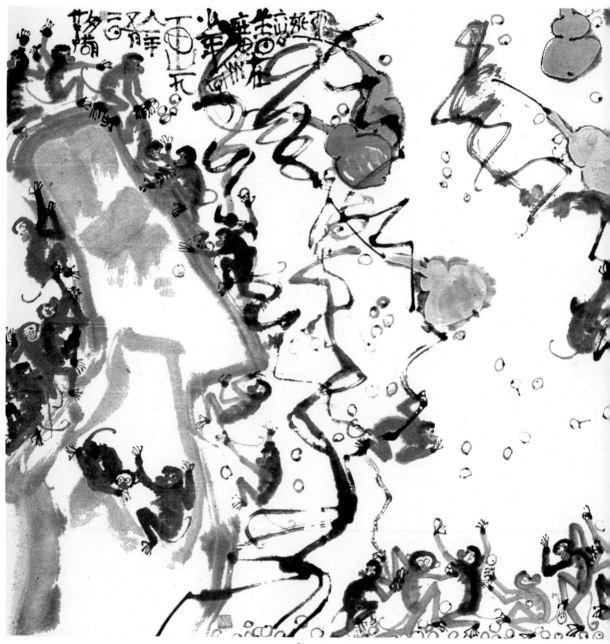

Birthday Celebration. 132cm × 68cm at six.

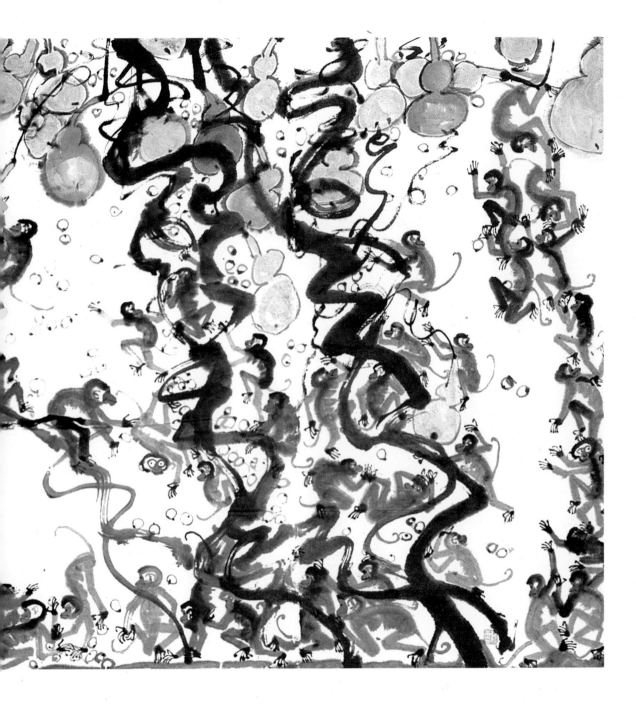

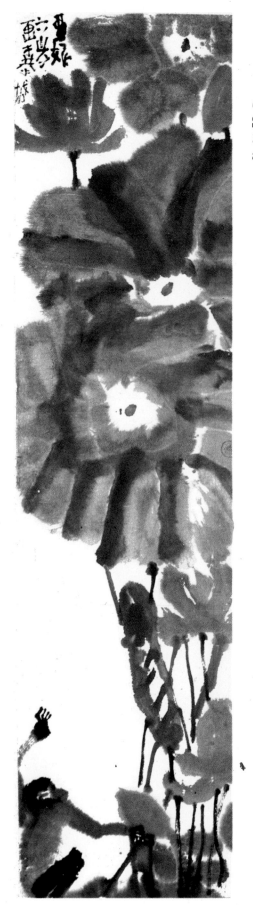

Gathering Lotus
Seeds.
33cm × 132cm
at six.

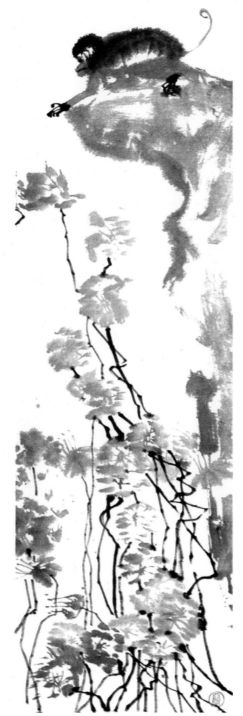

Beautiful Wild Flowers.
33cm × 132cm at six.

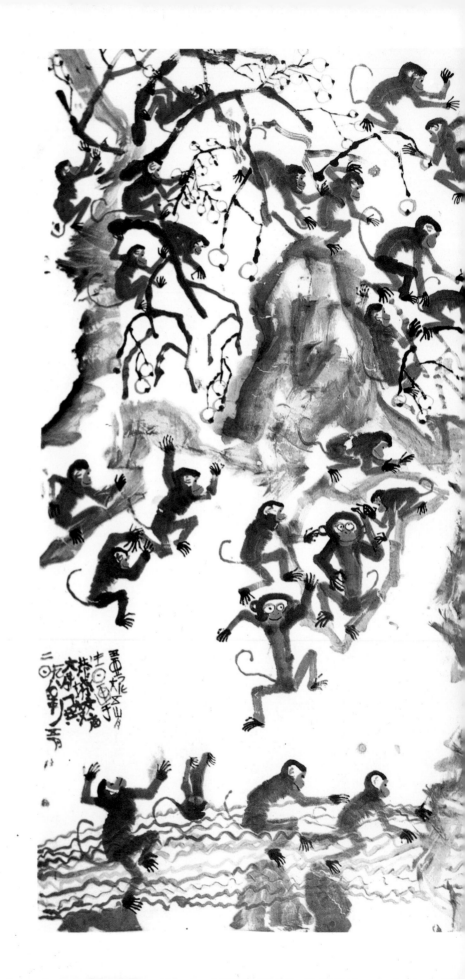

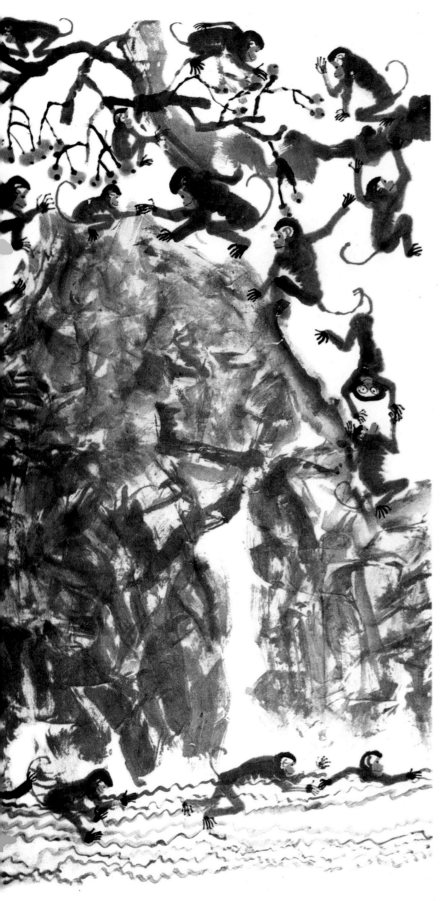

**Fifth Birthday
Celebration.
132cm × 68cm
at five.**

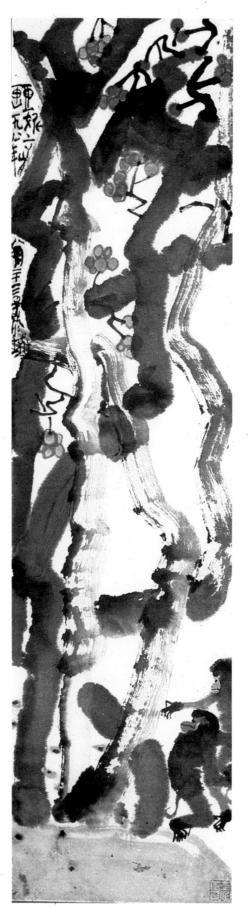

Plums in Full Bloom.
33cm × 132cm at six.

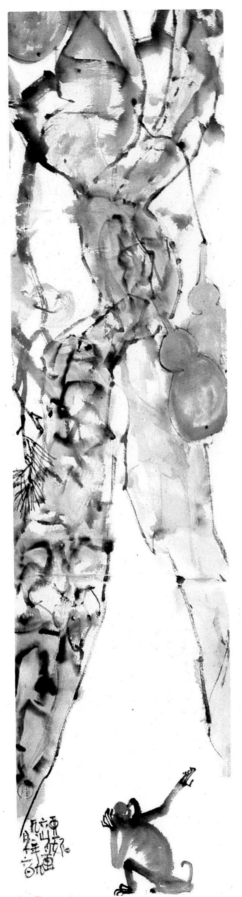

"I have two gourds here."
33cm × 132cm at six.

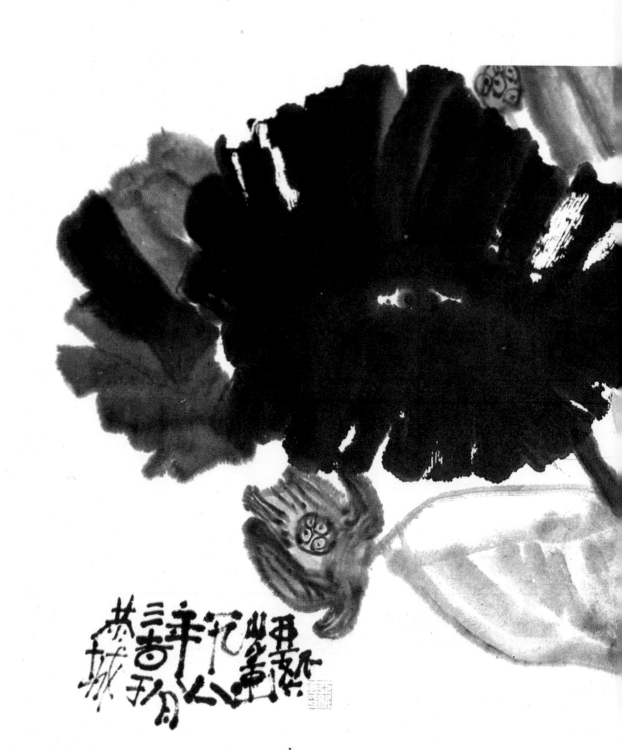

Lotus in Full Bloom. 66cm × 132cm , at six.

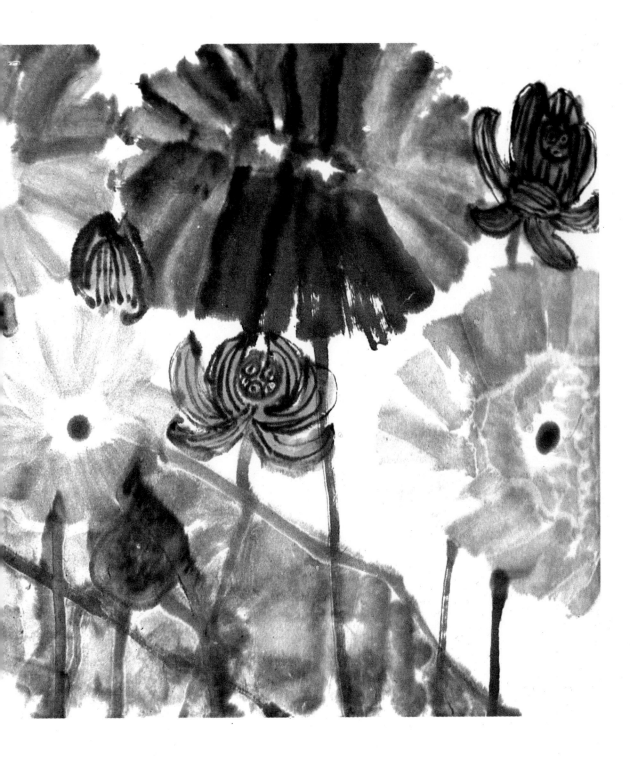

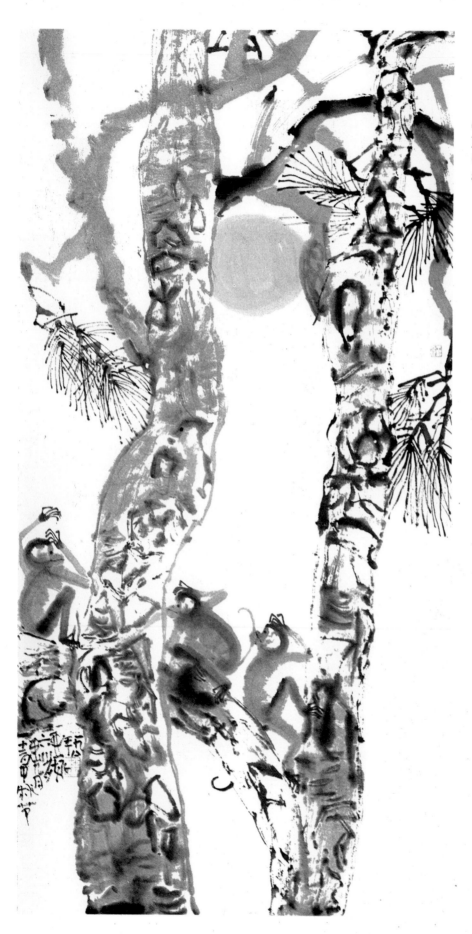

Gazing at the
Moon.
66cm × 132cm
at six.